K-POP

Style

K-POP
Style

*Fashion, Skin-Care,
Make-Up, Lifestyle, and More*

DIANNE PINEDA-KIM

Racehorse Publishing

Racehorse Publishing books may be purchased in bulk at special discounts for sales promotion, corporate gifts, fund-raising, or educational purposes. Special editions can also be created to specifications. For details, contact the Special Sales Department, Skyhorse Publishing, 307 West 36th Street, 11th Floor, New York, NY 10018 or info@skyhorsepublishing.com.

Racehorse Publishing™ is a pending trademark of Skyhorse Publishing, Inc.®, a Delaware corporation.

Visit our website at www.skyhorsepublishing.com.

10 9 8 7 6 5 4 3 2 1

Library of Congress Cataloging-in-Publication Data is available on file.

Cover Photo Photographer: Rxandy Capinpin
Cover Photo Stylist: RJ Roque
Cover Photo Models: Jiyong Park and Mika Melitante
Interior Photography: Various

Print ISBN: 978-1-63158-404-6
E-Book ISBN: 978-1-63158-405-3

Printed in China

CONTENTS

Chapter 1:

FASHION WORLD TAKES NOTICE OF A K-POP STAR

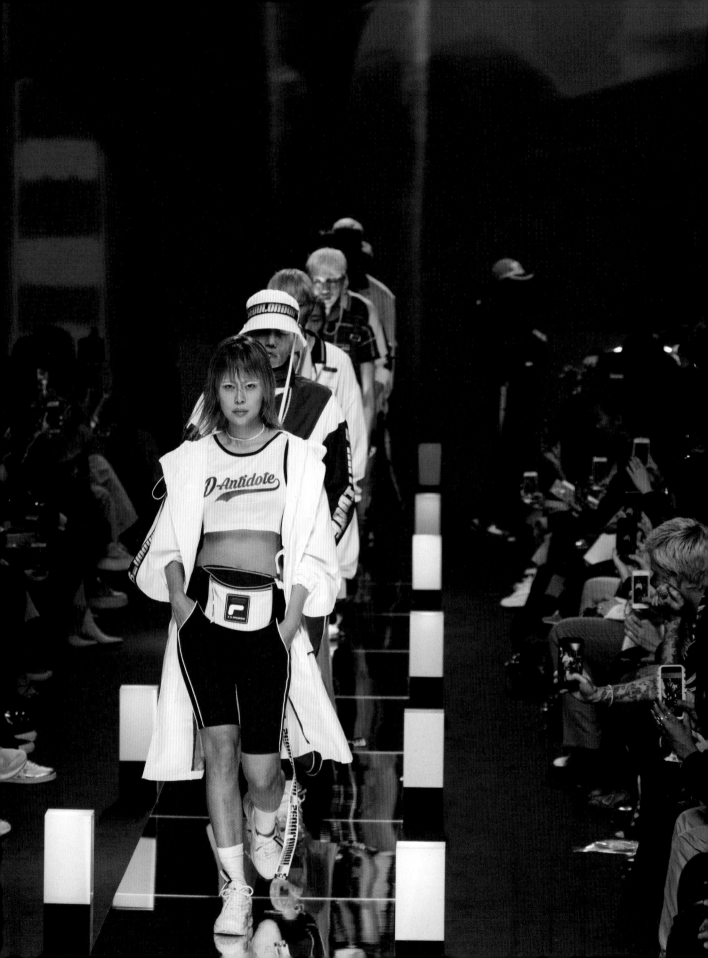

FASHION WORLD TAKES NOTICE OF A K-POP STAR

Paris Fashion Week 2012—While the paparazzi were busy taking photos of celebrity guests and regular street-style stars who made their way into the venue, a crowd started screaming and running toward one guy whose hair was entirely dyed a striking shade of pink. He walked with ease and familiarity as he sat front row at the Rick Owens show, wearing oversized specs, a formfitting black knit sweater, jeans with gold studs, a garish belt, dressed-up sneaks, and lots of silver bling piled one on top of the other. His style was no doubt eccentric and his sartorial sense unique, but his cool nonchalance and mysterious aura made him look like he fit right in. His style was incredibly rebellious as he stood out among the Western crowd who were dressed impeccably from head to toe. Everyone, including the exclusive fashion set, was intrigued, whispering, "Who is *that* guy?"

His name is G-Dragon or GD, one of South Korea's most popular rappers and leader of the boy band Big Bang, whose two-day debut in the Paris couture season would signal the beginning of his permanent status on the radar of high-fashion designers, magazine editors, and street-style photographers.

Back home in South Korea and all over Asia, he is anything but obscure. He is recognized as an artist whose music is as avant-garde as his fashion. "I think Korean style is becoming more and more diverse, and people are starting to gain a lot of interest, so I'm having fun seeing the new styles and trying them on," GD said in an interview with *Dazed*.

Since his entry into the big league of Fashion Week shows, GD has forged friendships with Virgil Abloh (who was then a budding streetwear designer, now creative director of Louis Vuitton), designers for brands like Balmain, Givenchy, Thom Browne, and, most importantly, one of the most acclaimed designers of our time—Karl Lagerfeld of Chanel.

So it wasn't a surprise when Lagerfeld introduced GD to the world as one of the new members of his circle of favorite muses that includes Cara Delevingne, Diane Kruger, and Sarah Jessica Parker. The *Business of Fashion* (BoF) wrote: "When

<< **Photographer: Izzy Schreiber**
D'Antidote captured the bright and energetic athleisure style of Korean fashion.

Karl Lagerfeld included G-Dragon in a group photo at the latest Chanel couture show alongside international A-listers like Kristen Stewart and Julianne Moore, it helped elevate the Korean rapper's status as an 'it boy' even higher." In 2017, the same publication named GD as one of the BoF "500 People Shaping the Global Fashion Industry."

THE RISE OF K-POP AS A TRENDSETTER

Back then, Korean music and its corresponding style were not considered "cool," and Korean fashion hadn't yet found its identity. The 90s pop stars tried to dress like typical suburban kids from the West: in low-rise, oversized jeans, mismatched colors, and a whole lot of hair spray.

Two decades ago, Korean food like kimchi, bibimbap, and *samgyupsal* and beauty products like BB and CC Creams were alien to the rest of the world. But these were introduced to the international scene through K-Dramas that are dubbed in different languages and distributed with English subtitles.

Korean American writer Euny Hong, author of the book *The Birth of Korean Cool: How One Nation Is Conquering the World through Pop Culture*, recounts South Korea's rags-to-riches story and how it transitioned from being one of the world's poorest and least fashionable countries to being the cultural superpower that it is today.

Aside from the major political changes and modernization that South Korea was able to accomplish at a rapid pace, its entertainment industry was also rising to the occasion. Hong writes, "K-dramas are soft power in action; they subtly and overtly promote Korean values, images, and tastes to their international audience."

She added further that in Taiwan, "the airtime devoted to Korean dramas was getting so out of control that in 2012, Taiwan's National Communications Commission called upon a Taiwanese network to reduce its primetime showings of Korean programs and increase the number of hours devoted to non-Korean shows." Latin American countries have also caught on to the trend, perhaps "because of their emotional similarity to *telenovelas*."

This cultural phenomenon is called "*hallyu*," which literally translates to "wave." It refers to the idea that Korea's tangible and intangible products like music, dramas, food, cosmetics, and fashion are the main drivers of its economy and culture in terms of its widespread popularity overseas.

In 2015, when Lagerfeld brought his infamous Chanel Cruise show to the futuristic creation of Zaha Hadid—the Dongdaemun Design Plaza in the heart of Seoul—he sensed that the world would soon be obsessed with South Korea. Lagerfeld observed that the locals "live very much in the present," positioning

themselves at the forefront of the latest trends. "Look at the streets here, they are young and playful," he said. One of the models in his show walked the runway in an outfit inspired by the *hanbok*, an article of traditional Korean clothing, and one of his designs featured the classic Chanel tweed suit with an unmistakable Korean twist.

It was a refreshing and smart move for such an established house of fashion to look toward Asia as its next biggest inspiration, more because of the fact that the Chanel Cruise show was sitting at the center of a nation that is now known as a cultural trendsetter.

This is why several big fashion players are placing their bets on this small country that is always one step ahead of its neighbors when it comes to globalization. For instance, the world's largest luxury brand's private equity arm, LVMH, invested up to $80 million in YG Entertainment Inc., a record label and talent agency in South Korea that's behind some of the country's largest acts (including G-Dragon). The deal was of mutual benefit: The Korean idols get access to the best fashion houses, while the brands will enjoy immense exposure in this flourishing market. And this was announced even before Lagerfeld's love affair with South Korea.

It's also no wonder that brands are eyeing this phenomenon that has captured the whole world's attention. Korean pop music, or simply K-Pop, is expanding on the strong foothold it has established in the United States, Europe, the Middle East, and South America. It's already reached its peak in its neighboring countries like China, Japan, Philippines, and Thailand, among many others. *Time Magazine* cited the genre as one of South Korea's greatest exports, aside from cars, mobile phones, and consumer goods.

Suddenly, the world is looking to South Korea for the latest "it" items and trends, bringing this once-mysterious small country with a population of roughly 50 million into the global spotlight.

THE BIG "CROSSOVER"

It is also important to note how K-Pop widened its reach toward the West after its success in Asia. Several acts had tried and ultimately failed to crack this highly selective yet unpredictable market—until one man did. And he came dancing like a cowboy.

Many people have heard of Psy's ubiquitous 2012 hit, "Gangnam Style," which raked up a total of 3 billion views on YouTube, earning his video the title of the most-watched clip, until someone else dethroned it in 2017. Without a doubt, Psy was one of the first people to enjoy what it means to "go viral."

But even before Psy, several South Korean acts had challenged the scene in the United States. Wonder Girls, a five-member girl group, broke into the Billboard Hot 100 charts with their catchy song, "Nobody," which enabled them to perform as the opening act for the Jonas Brothers'

world tour in 2009. In 2006, Rain, a solo singer and actor, made it onto the list of *Time*'s "100 Most Influential People Who Shape Our World." He performed a sold-out two-day concert at Madison Square Garden in New York City.

Fast-forward to today. Beyond the Scene (BTS)—a seven-member Korean boy band that was once considered an "underdog" in their home country—made history with their debut US TV performance at the 2017 American Music Awards. And what makes it even more astounding is that the group did it with their all-Korean-language songs.

Eve Tan, Singapore-based team leader for Asian content at Spotify, has also recognized this unique achievement. "For a genre that is in a different language and from a very different culture, it is very inspiring to see how K-Pop is making its mark on the global stage."

Today's highly connected world and social-media-savvy youth certainly have contributed to this Korean phenomenon, as opposed to yesteryear's slow but steady organic movement. Joon Ahn, executive vice president for the music business division at Korea's CJ Entertainment & Media, told grammy.com in an interview, "The channel for movement of music is now very simple with digital. Compared to movies, musical theater, or TV series that have a bigger language barrier, music's appeal is communicated through rhythm and visual impact. YouTube and other social networks have contributed the most to spreading music of all kinds and allowing them to be heard by a greater audience."

FROM K-POP "IDOLS" TO FASHION "ICONS"

So what exactly is it about K-Pop that makes the world swoon? And consequently, how did the stars transition from being K-Pop idols to global fashion icons?

There are definitive elements that make K-Pop a hit: exceptional visuals (in all aspects like physical appearance, ways of dress, and demeanor), high-quality performance (slick dance moves, amazing vocals, high-budget music video and stage production), and an overall wholesome image.

Aja Romano writes in her article for *Vox*, "How K-Pop Became a Global Phenomenon": "Their fun, singable melodies make it clear that the South Korean music industry has perfected the pop production machine into an effervescent assembly line of ridiculously catchy tunes sung by ridiculously talented people in ridiculously splashy videos. They're sending a message to the world that South Korea is modern but wholesome, colorful, inviting, and fun."

At the tail end of this *hallyu* wave, aside from the music and dramas that transcended language and cultural barriers, is the fashion that came with it.

"*Hallyu* is indefinable without fashion," said singer Jiyul of K-Pop girl band Dal

Shabet. "Fashion has influenced K-Pop in many ways, allowing celebrities, like myself, to look their best when performing on stage. It also provides opportunities for those outside Korea to know the country and culture better. K-Pop would not be where it is today without fashion."

Aside from entertainment, K-Pop has solidified its status as a commercial juggernaut in terms of its marketability in fashion. Everything that a K-Pop idol wears gets sold out within weeks after he or she is photographed onstage, on the way to the airport, or on the streets.

When it comes to influential K-Pop fashion icons, on top of the list is CL (Chaerin Lee), an edgy female rapper and the former leader of girl group 2NE1, who released an English-language LP called *Lifted* in the United States.

Back in 2009, Jeremy Scott, the designer of his namesake label and now Moschino creative director, saw CL in a music video, which resulted in a friendship between them as designer and muse. Jeremy exclaimed, "I want to do a shoot with her. I want to meet her. I love her. I'm obsessed!"

"Fashion and music are connected since both are expressions," CL told *i-D*. "Whatever I wear, I feel like I could play this character onstage; it gets me into that zone."

She also described how fans are always searching for somebody to look up to in terms of style. Ultimately, K-Pop provides a wealth of stars that can provide this creative fashion outlet. "I think a lot of the young kids right now are looking for something new, and they want to look different," CL told *Paper Magazine.*

Jessica Jung, solo singer and former member of a hugely popular girl group, Girls' Generation, is another testament to K-Pop's trickle-down effect when it comes to fashion. After leaving the group, she went on to create her own label, Blanc & Eclare, which has branches in China, Hong Kong, Thailand, Canada, and SoHo in New York. Being a K-Pop star certainly elevated her brand's prominence, but her keen eye for style and her business acumen allowed her to be a success in the fashion world. "I've been in the music industry as a singer for the last 10 years," she told *NBC News.* "Fashion has always been a passion of mine, so I'm just really happy that I can pursue both things."

Despite trying to conquer a whole new territory, she never fails to look back at K-Pop as a huge key to her success and as something she'll always be proud of. She told *Elle* magazine, "I hope [K-Pop's moment in the United States] goes on for a long time. I hope that a lot of people appreciate it more and listen to it more. I think Koreans, they're really hard-working people. They're really innovative, and they try new things all the time so I think it's just a matter of time when everyone will know K-Pop."

Chapter 2:

A GUIDE TO K-POP STYLE

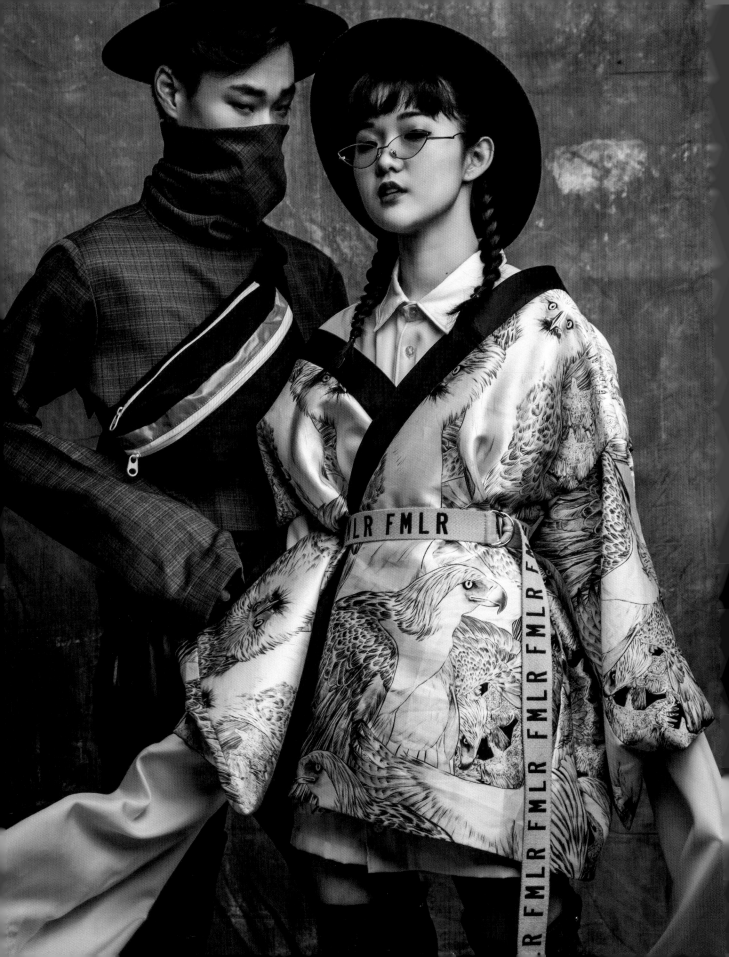

CHAPTER 2

A GUIDE TO K-POP STYLE: OVER-THE-TOP K-POP

Clashing colors, bright prints, unique silhouettes, heavy makeup, or coordinated chaos—there's really not one specific definition for what makes K-Pop style. It could go from vibrant, loud, and downright outlandish to wearable and minimalist looks.

But one thing's for sure: Fashion is used to define the kind of image or concept that a certain artist or group wants to portray, whether it's a sense of empowerment or pure innocence.

Photo Credits
Photographer: Rxandy Capinpin (@rxandy)
Photographer's Assistant: Antonio Vazquez
Fashion Stylist: RJ Roque (@rjroquestar)
Stylist's Assistant: Louie Roque (@babochoreom)
Makeup Artist: Mika Puyat (@mikasaidso)
Hairstylist: JA Feliciano (@jafeliciano)
Models: Mika Melitante (@reinsmika) and Ji Yong Park (@park_ji_yong00)

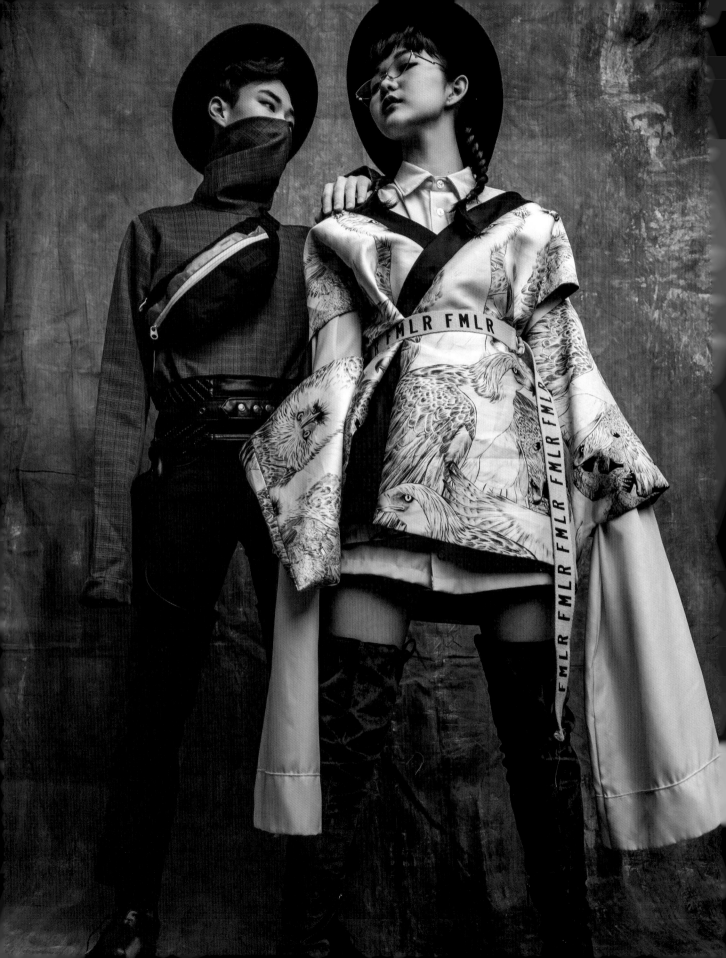

I. ECCENTRIC LUXE

Inspired by G-Dragon's The Act III: M.O.T.T.E. 'Moment of Truth The End' World Tour

"Don't be afraid. There's no right answer in fashion." This is GD's mantra when it comes to style, and this seems to be his guiding principle when it comes to his affinity for mixing high-end designer pieces with more raw and approachable street brands. *Dazed* magazine praised his groundbreaking sense of style, saying, "He has become a legitimate style icon not only in luxury fashion but streetwear—a cool, successful and self-assured figurehead for Korea's fast-rising presence in the fashion market."

He is fearless and oftentimes controversial when it comes to his fashion choices, and his over-the-top, androgynous taste lands him in the headlines. This makes some people admire him even more and earned him the nods of numerous style experts and award-giving bodies in fashion.

Aside from his creative expressions both in music and experimental personal style, he's had a long list of pursuits in fashion: he's done collaborations with Hedi Slimane, Giuseppe Zanotti, Jeremy Scott, and Raf Simons; has designed his own jewelry collection with Chow Tai Fook; and ultimately created his own brand, PeaceMinusOne.

Vogue summed up GD's powerful impact: "His chameleon-like style and

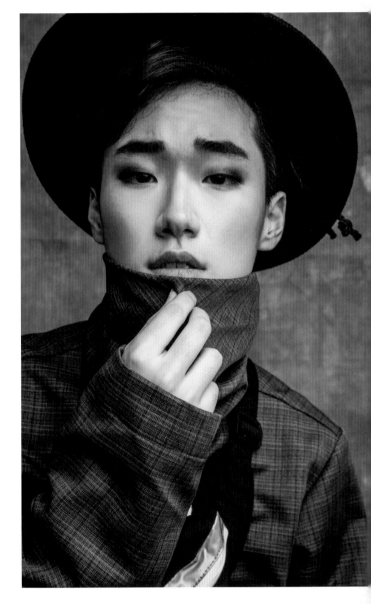

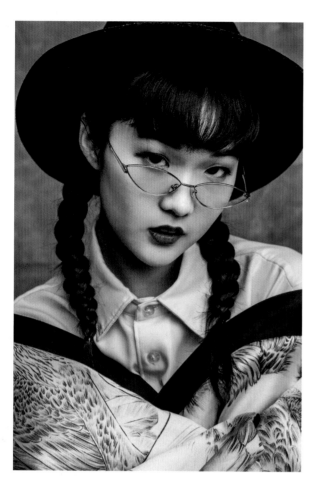
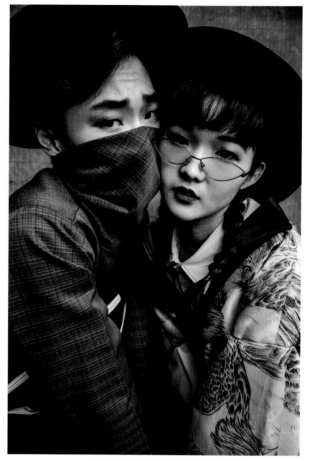

irrepressible persona continue to set hearts aflutter—his is an aura and aesthetic where, for some, it's not merely enough to just aspire to date him, but to *be* him."

This style pictured here is inspired by his concert wardrobe for The Act III: M.O.T.T.E. 'Moment of Truth The End' World Tour, where he injected traditional Korean elements with modern looks. Through this tour, he explored the duality of his identity: baring his soul as the simple and humble Kwon Ji Yong (his real name) while enthralling the audiences with his rebellious stage performances as G-Dragon. Surely it's hard to emulate his signature style, but he gave this simple tip: "I just try to look good, always."

2. HIP-HOP PUNK

Inspired by Red Velvet's "Bad Boy"

In K-Pop, there are two defining images that most girl groups embody: either daring and edgy, or wholesome and cute. But when four-member girl group Red Velvet debuted, they didn't want to subscribe to either of these concepts. They wanted to be both. They took on the challenge of having a dual concept that shows their

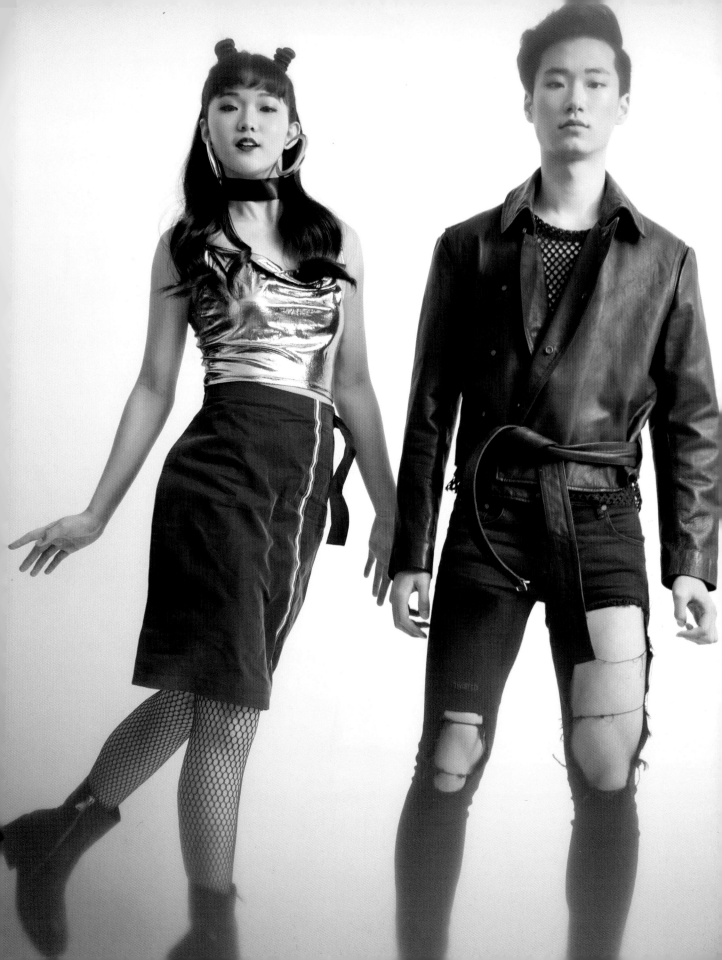

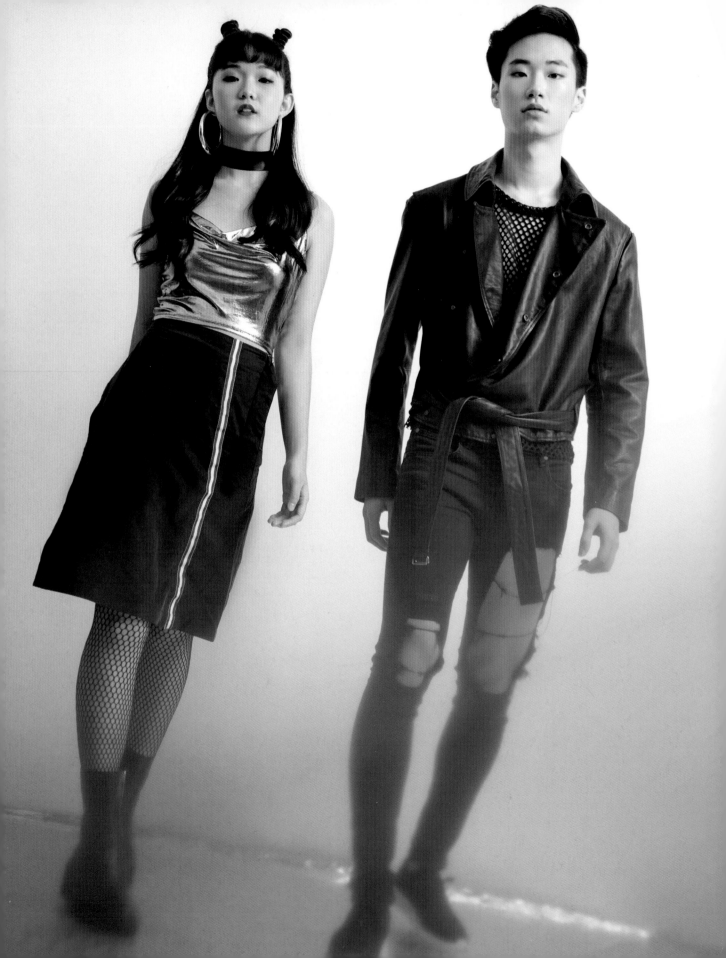

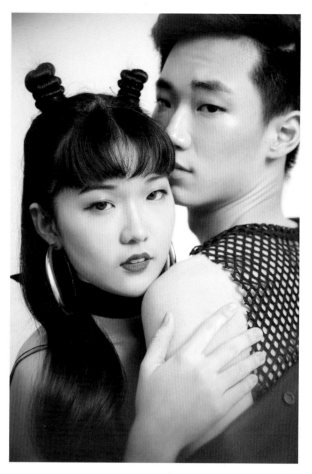

well-rounded talents in preppy pop music ("Red") and smooth R&B ("Velvet") sounds. *Dazed* couldn't have described them better: "They're neither sexy nor innocent, with music videos that are often dark, trippy, sinister, or haunting, even when they're flooded in pastel colors."

Quirky is the word that best describes them, and their styles are as flexible as their images. In their "Bad Boy" release, they were embarking on a more subdued music and style, reflecting their "Velvet" persona. The R&B-inspired K-Pop single debuted at No. 2 on *Billboard*'s World Digital Song Sales chart, selling 4,000

downloads in its first week, according to Nielsen Music.

"We showed a lot of red style, and it's been very bright," leader Irene told *Billboard* in an interview. "We feel like we want to show a more perfect side to ourselves, more perfect music. An upgraded version of what we can show of the velvet concept."

The girls sported an unexpected combination of all-black hip-hop and punk looks, with fishnet-infused styles and edgy streetwear, which completed their persona of the "femme fatale" who's out to destroy the "bad boy."

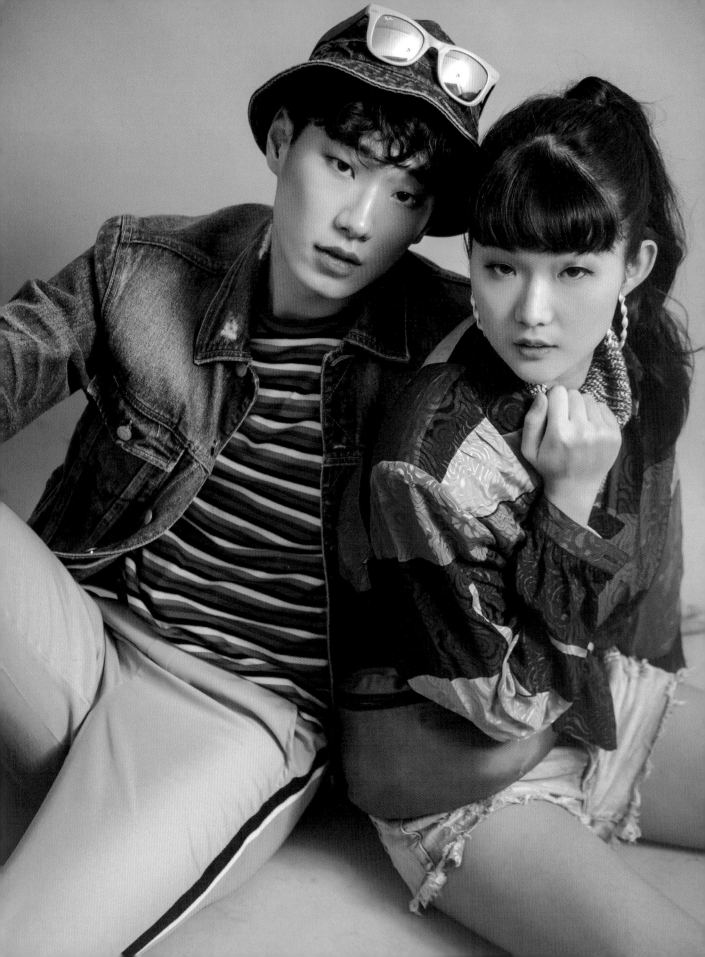

3. ECLECTIC HIP-POP

Inspired by BTS' "DNA"

If there's any K-Pop group who is enjoying what it truly means to "break out" into the immensely wide Western market, it has to be BTS (which stands for "Bangtan Sonyeondan" in Korean and was later changed to "Beyond the Scene"). The seven-member group has already racked up several accolades: BTS is the first South Korean act to reach 10 million followers on Twitter; the first K-Pop group to perform at the American Music Awards, where they achieved a Guinness World Record for most Twitter engagements; and the first South Korean group to win a Billboard Music Award. They have a millions-strong fanbase all over the world, which they captured through their unique sound, sharp choreography, high-level production, and ultimately, their charming and down-to-earth personalities. Their constant presence in social media also helped fuel their success.

Whenever they travel to the United States, fans camp out and wait for hours just to see them land at the airport and line up in endless queues for their concert, with

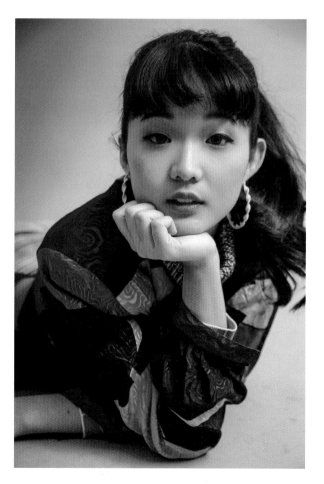

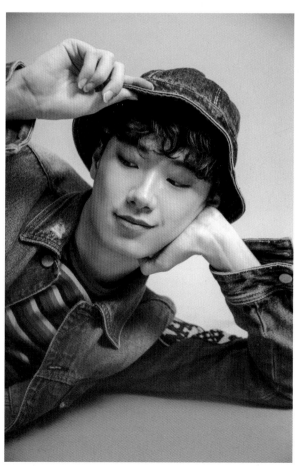

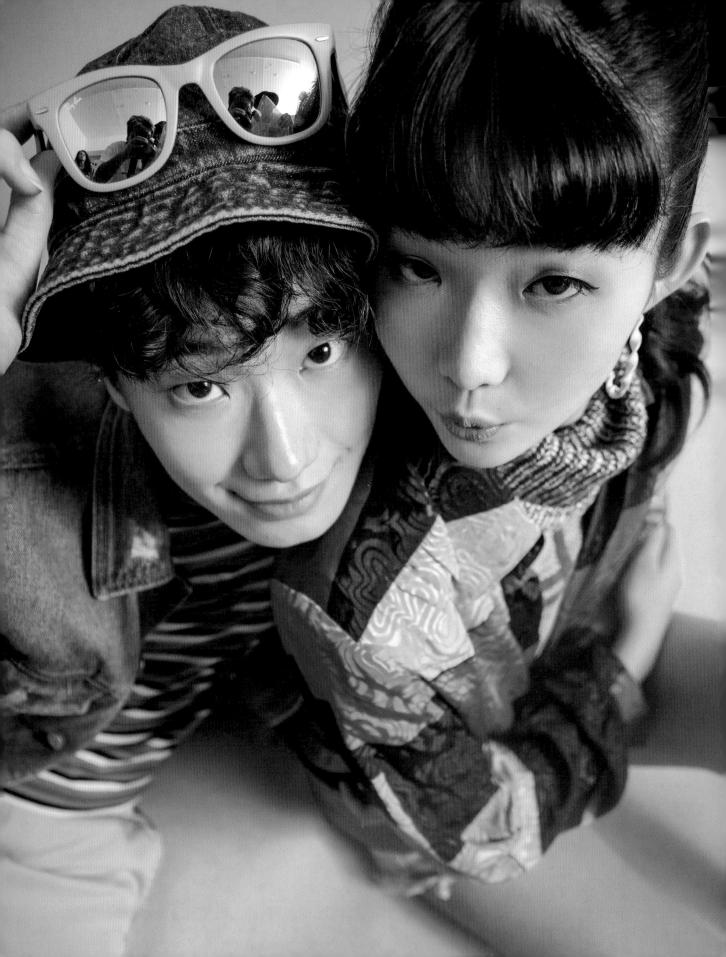

some even bursting into tears upon seeing their idols perform. In BTS' first US TV appearance on *Ellen*, talk show host Ellen DeGeneres described their fans' reaction as similar to that of the Beatlemania of the 1960s.

When it comes to fashion, BTS is considered one of the most watched groups that set the trends. Offstage, they always wear a combination of clean-cut, classic designer pieces and cool streetwear styles. Member V is known as "Gucci Boy" to fans because of his penchant for wearing the brand in his daily looks, while J-Hope is the one who is most up-to-date with street-style trends. All the other members have unique individual styles as well.

But onstage is where they're more experimental. They often have dark, strong, and mysterious concepts, but for their song "DNA," which is the inspiration for the styles pictured here, the band wore a mix of bright colors, prints, and sporty pieces. This is also the song they performed at the AMAs, wearing outfits that were as vibrant as their high-powered performance.

For BTS, it's not so much about wearing particular brands or styles, it's more about the attitude. J-Hope told *Billboard* in an interview, "Our attitude changes as we try to express ourselves and perform; it feels very different depending on the clothing." Leader RM continues, "Music and fashion are like the two best ways to express and prove oneself to the world."

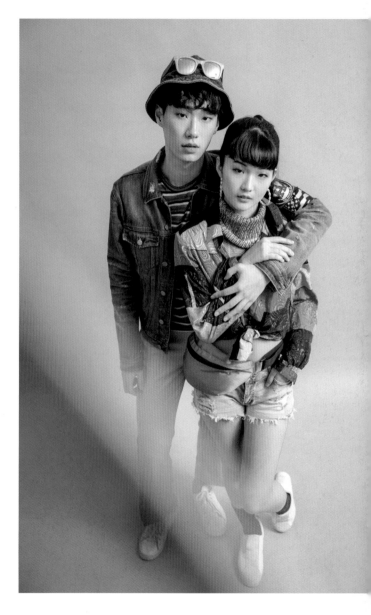

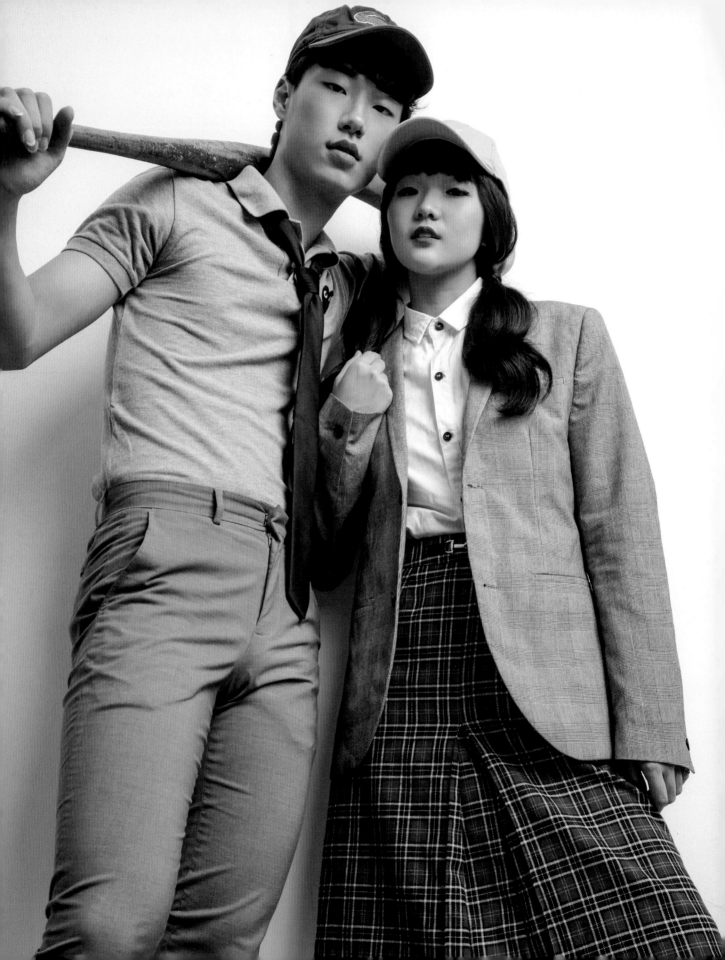

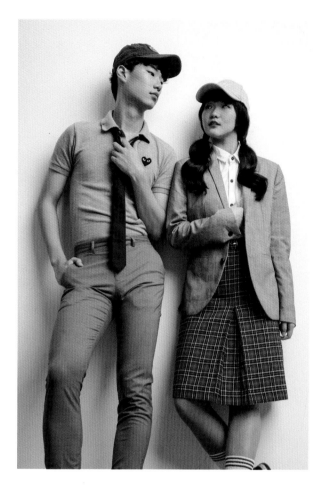

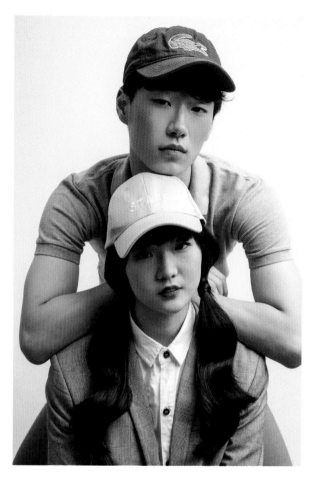

4. THE QUINTESSENTIAL PREPPY

Inspired by EXO's "Growl"

At the closing ceremony of the PyeongChang Olympics in South Korea, one of the performers elicited the loudest cheers and garnered more than five million tweets: EXO. The lead dancer of the group, Kai, performed a haunting and stunning solo dance number while wearing Korea's national costume, accompanied by a cymbal player. Soon after, he was joined by the other members, who rode in dune buggies as they circled the massive stage.

Wearing outfits like the cool kids at an elite prep school, the group performed two of their biggest hits, "Power" and "Growl." It was a huge, once-in-a-lifetime moment for them as one of the biggest names in K-Pop.

The hip-hop track "Growl" wasn't their debut single, but it was no doubt their biggest breakout song and enabled them to make a clean sweep of all the music programs and award shows in South Korea. Its accompanying LP, *XOXO,* debuted at No. 1 on the World Albums chart.

Their schoolboy concept wasn't anything new in K-Pop, where scores of groups wear uniform-inspired costumes, but their killer dance moves and cool, delinquent vibe made them stand out.

That was five years ago, and today, they not only reign in the charts but also in fashion circles. *Vogue* published an article titled "Is EXO the Most Stylish K-Pop Band of All Time?" in which the writer notes how the band transitioned from uniformity to "slowly pushing the boundaries of K-Pop men's fashion" with their newly found distinct individual styles.

In fact, the band's lead singer, Baekhyun, launched his own clothing line as co-creative director of Privé by BBH, a unisex streetwear label, together with New York and Los Angeles–based fashion editor and stylist Danyl Geneciran. All over Asia, you can see EXO's faces on billboards and in magazines representing prominent beauty, apparel, and shoe brands. "I think we're bringing something new and current to the industry," Baekhyun said in an interview. It's definitely a different kind of "power" only they possess.

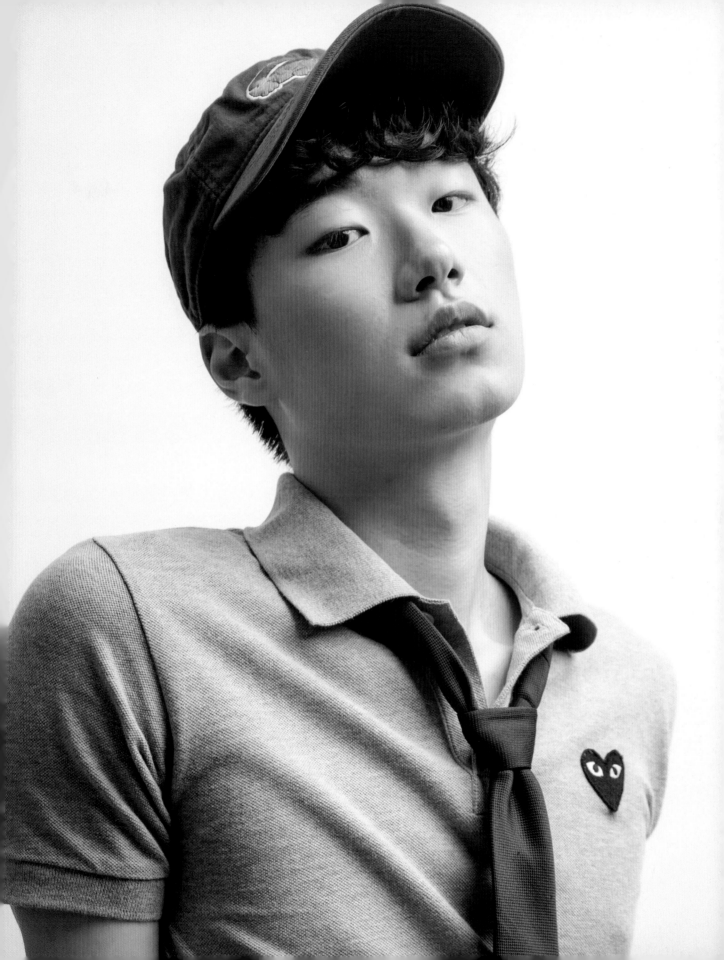

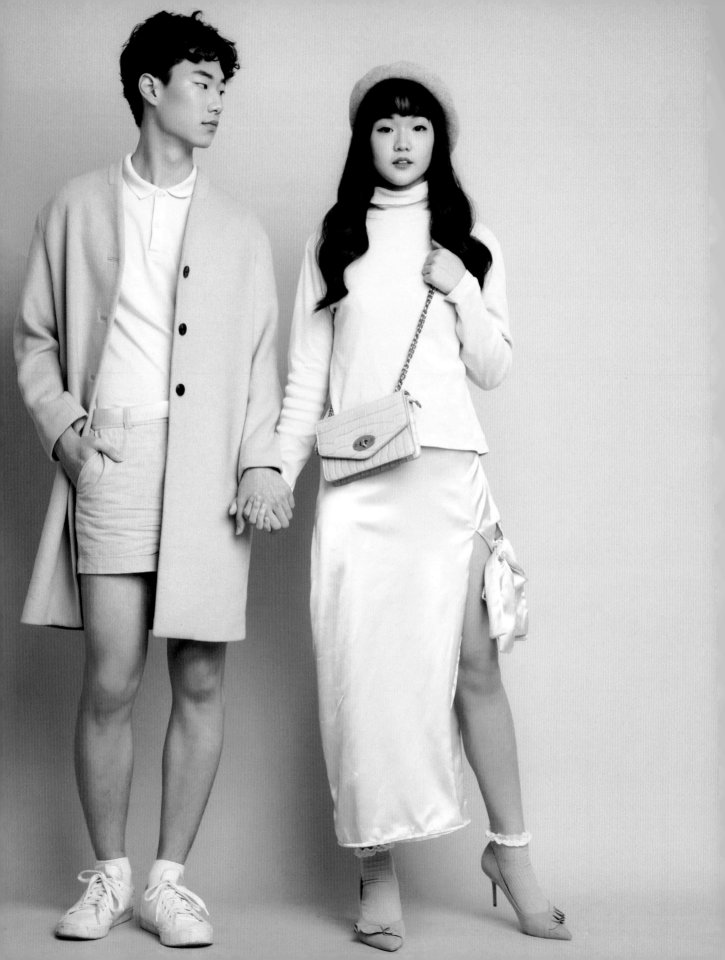

5. PASTEL EYE CANDY

Inspired by Twice's "TT"

They say nice guys finish last, but this does not seem to apply to K-Pop. If there's anything that sets the industry apart from its counterparts, it's the stars' clean, wholesome image that make them seem approachable and aspirational to the masses. Even dating is considered a "scandal," which is why both their public and private lives are heavily guarded. This is because most stars are considered as role models to the youth—and one girl group that lived up to this title is Twice.

Considered the darlings of K-Pop, the nine-member girl group made quite an impact in the Korean mainstream scene with their cute, friendly concept. Their songs are just as peppy, too. Their single from their second EP, "Cheer Up," aimed to do as the title says, and it became one of the country's irresistibly catchy songs that gave youth, the group's main demographic, an extra boost of motivation. They became such an overnight sensation that after only a couple of years, they are regarded as the group that's responsible for the success of their agency, JYP Entertainment Corporation, in the stock market.

Their music is described as "color pop," a bubblegum pop sound that is infused with electronica, jazz, and trap, among

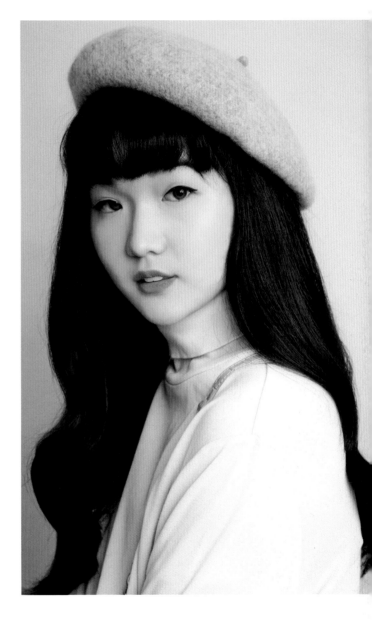

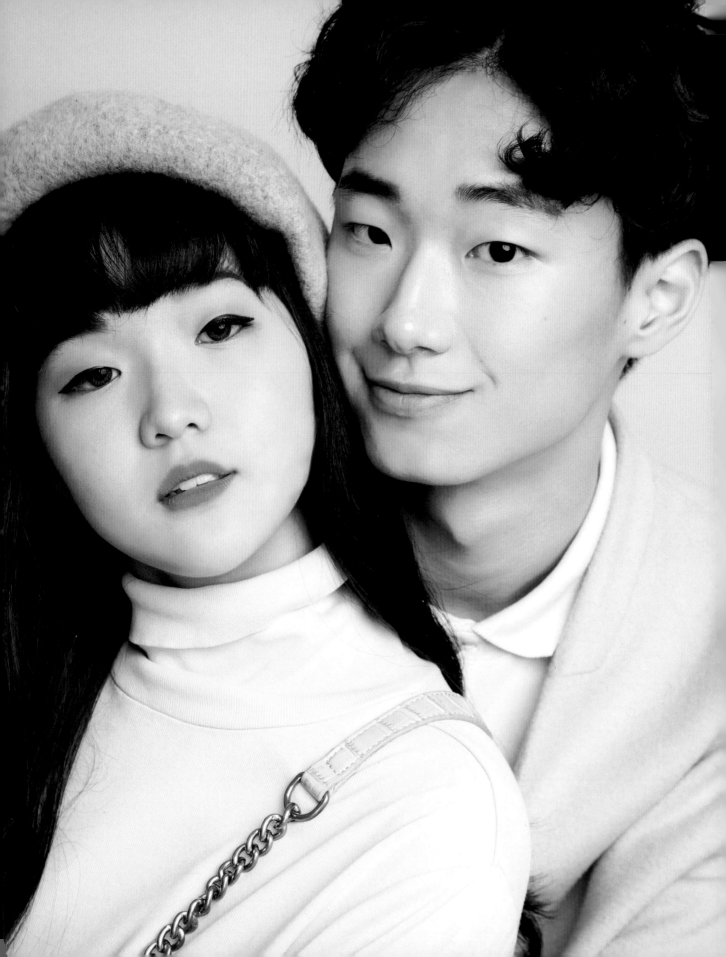

many others. This is evident in their highly infectious song, "TT," where their sound is as colorful as their outfits. In their music video and live stage performances for this song, they donned outfits with pastel hues of all pink, purple, and mint green, among many others, which highlighted their bright, adorable personalities.

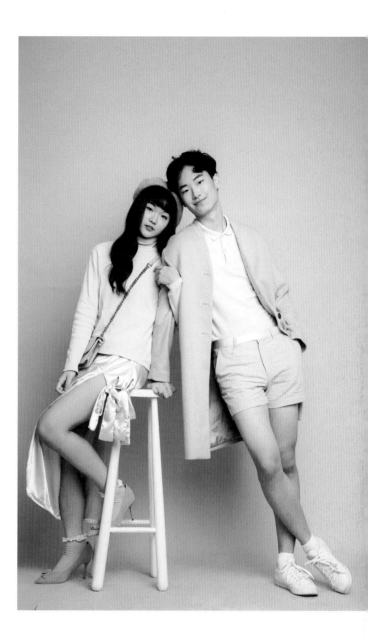

Chapter 3:

AN ATTAINABLE APPROACH TO K-POP STYLE

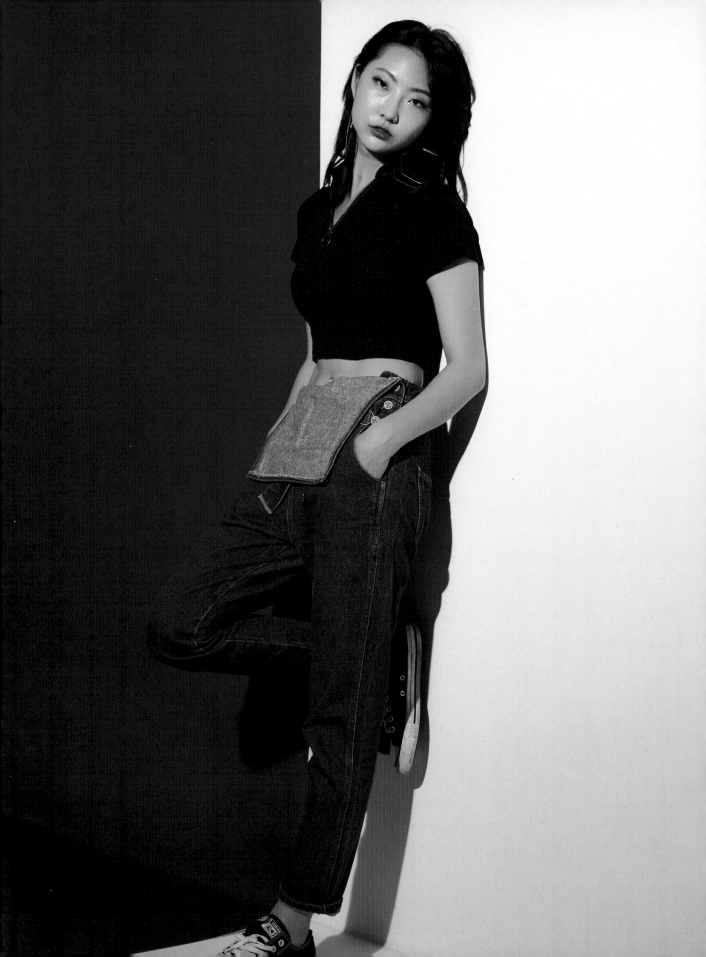

CHAPTER 3

AN ATTAINABLE APPROACH TO K-POP STYLE

Contrary to the common perception that K-Pop is always fashion-forward or zany, quite a lot of the stars' styles are inspired by the streets. Similarly, some of K-Pop's music and fashion concepts are derived from daily life stories like an experience of first love, heartbreak, or self-discovery.

Photo Credits
Photographer: Sewon Jun (@photo_hinkchi)
Fashion Stylist: Kyunghoon "Roy" Back (@roy_back)
Makeup and Hairstylist: Sooho Yoon (@charmantsoiree)
Models: Sunhee Kim (@_sunheekimm), Ziyoung An (@zizian_ber), Yujung Seo (@_ujng_), Youjin Oh, Sangah Kim (@sangvely94)

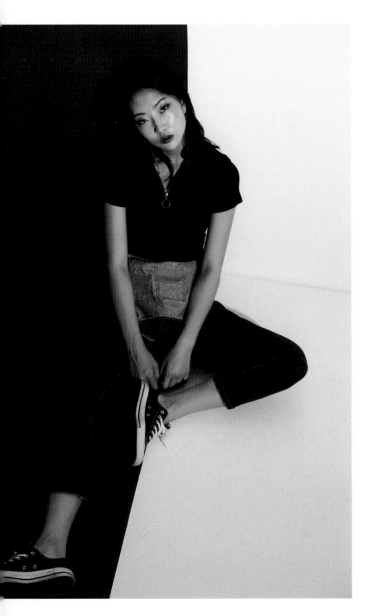

RETRO STREET

Inspired by EXID's "Lady"

Nowadays, retro styles both in sound and style are gaining solid ground, partly because old and young audiences are yearning for South Korea's golden age of pop music during the 1990s. EXID (short for "Exceed in Dreaming"), is a five-member girl group that challenged the '90s retro funk concept with their throwback hit song, "Lady."

The group is known for their sexy and daring concepts in lyrics and choreography, oftentimes pushing the boundaries of typical K-Pop standards. But EXID's rise to fame is a classic Cinderella story, where the band went through ups and downs before being recognized as one of K-Pop's representative girl groups.

Not being confined to the glossy image of the "good girl" enabled EXID to experiment with their styles. For their single "Lady," their entire wardrobe for the music video and stage performances brought back the glory of '90s fashion with hip-hop, sporty, and grunge styles: denim overalls, crop tops, baggy jeans, big logos, and sneakers. One of the members, LE, who used to be an underground rapper before joining the group, told *Paper* magazine, "When I was younger, I loved listening to female artists like Aaliyah and TLC. We tried our best to capture the reminiscent vibes of the '90s."

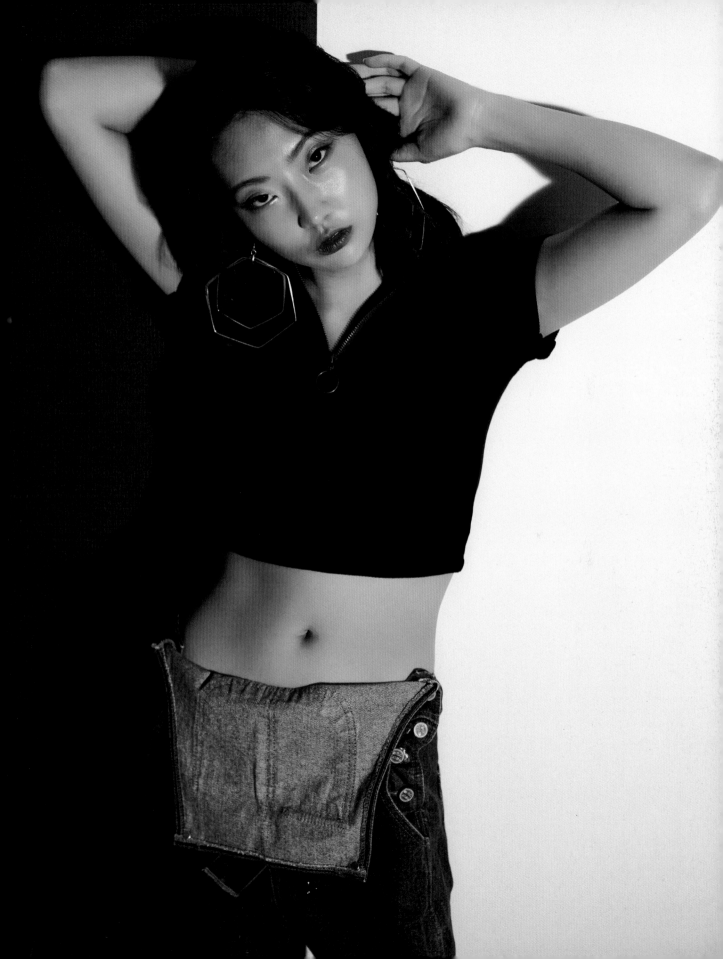

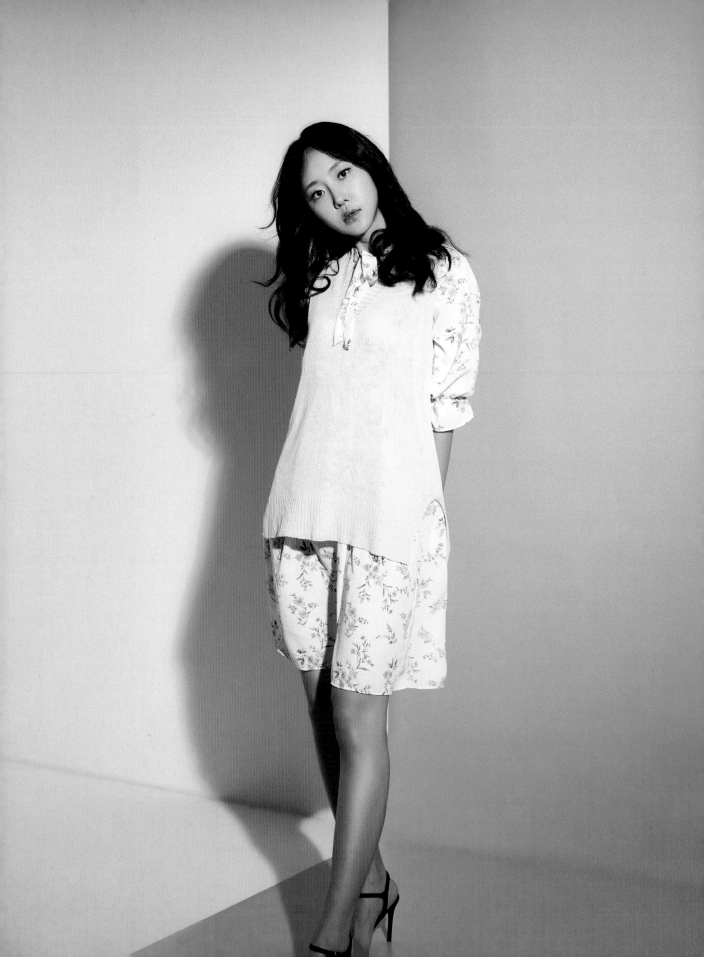

GIRL NEXT DOOR

Inspired by: IU's "Through the Night"

While most K-Pop groups try to capture audiences with shock factor both in visuals and sound, one solo singer dared to go the completely opposite way—through a more quiet, minimalist style. Dubbed the "nation's little sister," South Korea's term of endearment for a well-loved celebrity who is as precious to them as family, IU (real name Lee Ji-eun) is undoubtedly one of the most successful solo singers in K-Pop.

She burst onto the scene with her demure, relatable image and high-octave voice, garnering her a huge fanbase including kids as young as five years old. At the height of bubblegum pop and spectacular K-Pop performances, IU stood out the only way she knows how: with sheer talent. Not only does she have the voice of an angel, she is also an old soul, baring her thoughts and life experiences through songwriting. As her music matured, she single-handedly revived the folk, retro, and ballad genres that were popularized by guitar-playing Korean musicians in the '90s.

With her song "Through the Night," she brought audiences back to bygone years when music was played on vinyl records, with a sound that was stripped down to soft acoustics and highlighted her vocals. The song won several 2017 Song of the Year awards, and it remained undisputed at

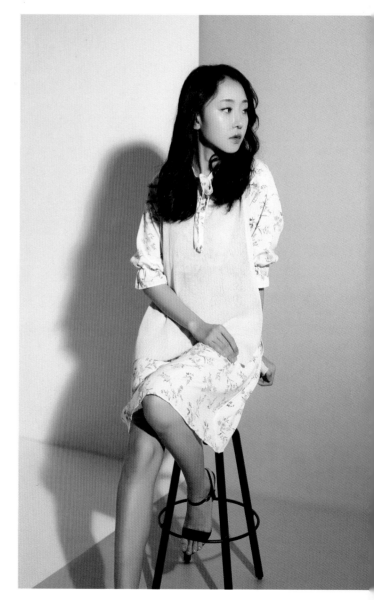

the top of the music charts at that time. IU explained, "When I wrote the lyrics for this song, I was dealing with serious insomnia. I wrote the lyrics because I thought if you have someone you love, it was right to hope for their sleep. My fans said that they heard it as a lullaby and were able to fall asleep to it."

Her style was reminiscent of the past, too. For her music video, she wore a neutral feminine dress that captured the time when everything was simple and true. Her hair and makeup were also kept to a bare minimum, portraying the sincerity of a girl who sings about missing someone through the night and wishing him pleasant dreams.

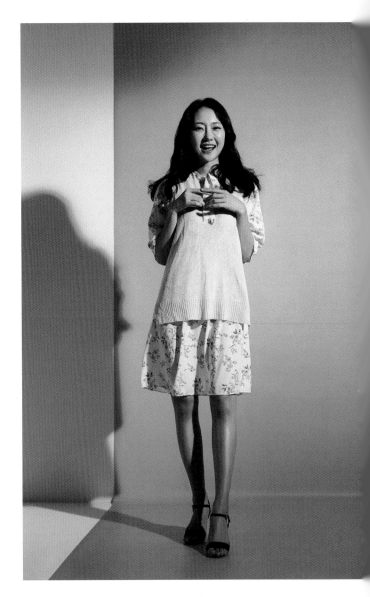

EDGY FEMININE

Inspired by: BLACKPINK's "Playing with Fire"

Beautiful, talented, smart, and stylish—four-member girl group BLACKPINK is ushering in a new image of girl power, with their ultra-trendy music videos and confident lyrics that define their unique identity: "We the only gang to run the game in high heels."

It's this perfectly balanced combination in a strong and feminine image that widens their following from lovestruck fanboys to girls who not only admire them, but want to *be* them.

"We go forward without holding back, no need to be cautious. Black then Pink, we're pretty savages," as they say in their song "DDU-DU DDU-DU," which became the fastest K-Pop music video to hit 250 million views on YouTube. Their debut single "Boombayah" made it into the top of Billboard's World Digital Songs Sales Chart, while the rest of their albums flew off the shelves. Coming from one of the "big three" entertainment agencies—YG Entertainment, which houses formidable acts G-Dragon and CL—BLACKPINK is the newest group to capture the hearts of Generation Z.

From the get-go, YG CEO Yang Hyun-suk wanted to create a hip-hop girl group that was both feminine and edgy, with BLACKPINK exceeding his expectations. The group's unapologetic confidence, relatable personalities, and influential sound

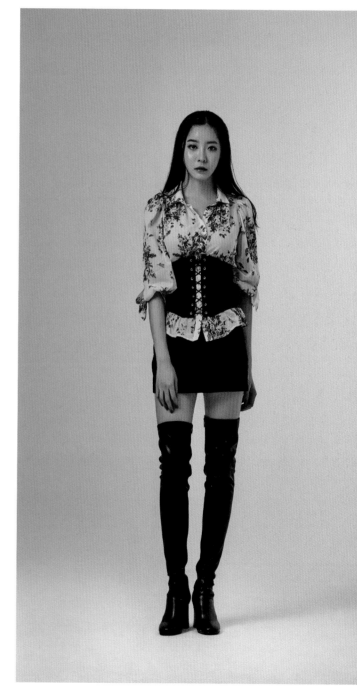

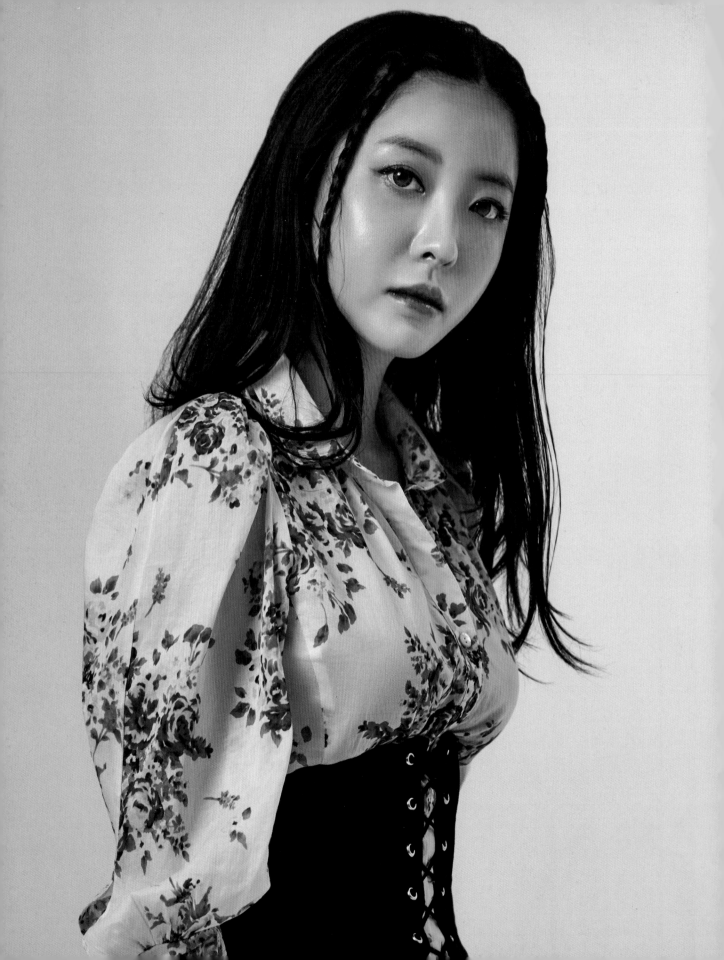

provided a fresh concept: why choose among sweet, friendly, fierce, or powerful images—when you can be all?

But what probably sets them apart is their luxurious and brazen fashion, which can go from wearable to aspirational, with the girls wearing not just any run-of-the-mill brands, but some of the world's most coveted high-fashion designer duds. "No other K-Pop [girl] group wore Alexander McQueen before, or Balenciaga, but designers have seen their sales go up so they are now eager to work with them," BLACKPINK's stylist Choi Kyoung Won told *WWD*.

The style featured here is inspired by their music video "Playing with Fire," where they wore an unlikely combination of soft and hard elements like florals, leather, corsets, and glam makeup. "Like our juxtaposed name, BLACKPINK, our style is a mix of strong and powerful but also girly," says lead singer Rosé in an interview with *Nylon*. "We always try to pull off some looks that we wouldn't have even imagined coming out with previously."

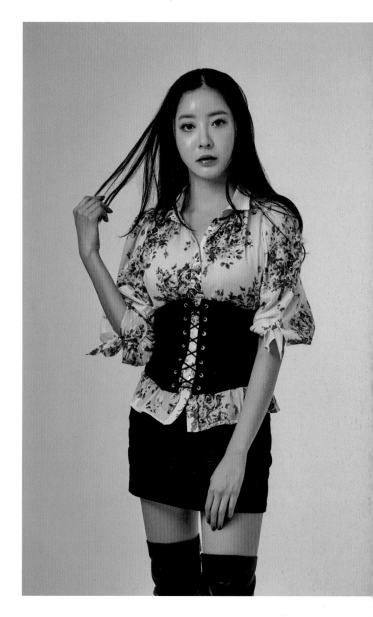

A TOUCH OF GLAM

Inspired by BoA's "One Shot, Two Shot"

Fans of the earlier generation of K-Pop will probably say that BoA Kwon is one of the first to lead the *hallyu* phenomenon as a singing and dancing prodigy who debuted at the young age of thirteen. Now thirty-one, BoA is renowned as the "Queen of K-Pop" who paved the way for today's K-Pop stars to venture outside of South Korea.

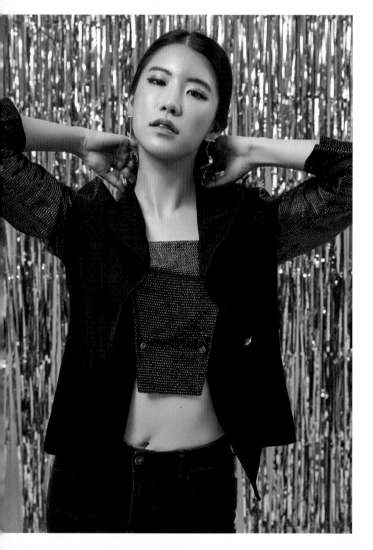

She's one of the first Korean singers to release a Japanese album, *Listen To My Heart*, which broke through Japan and Korea's tense relationship. Her three consecutive albums sold more than one million each in Japan, a feat that foreign artists rarely achieve in the highly exclusive J-Pop industry. She extended her reach toward the rest of Asia with her multilingual skills (she recorded in Korean, English, and Chinese), solid vocals, and slick dance moves.

As a next step to her career, she moved on to challenge the American music market, where she launched an English-language single, "Eat You Up," in October 2008, followed by her first all-English-language album, *BoA*. The album reached No. 3 on the Billboard Heatseekers Chart. She also starred in the dance movie *Make Your Move* with Derek Hough.

Her hip-hop and R&B music reflects her fashion, which is the very definition of a pop star: cropped tops, leather, street casuals, and a mix of glamorous and trendy styles. For her 2018 release "One Shot, Two Shot," the singer wore black with a touch of sparkle to portray a strong and alluring appeal.

As for her long-running career in K-Pop, she told *Billboard:* "I never thought that I would be a dancer this long term, you know? It's [sic] really blessed that I can still go on stage as a performer, and I will keep making great sounds and performances as much as you guys expect of my music."

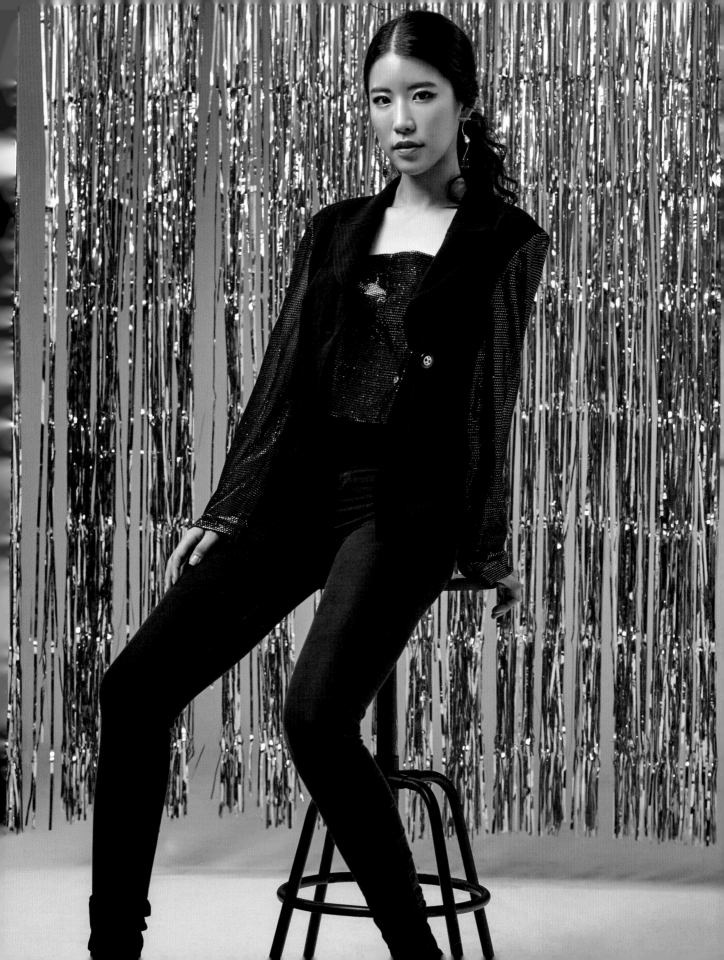

Chapter 4:

FROM THE SCREENS TO THE STREETS

FROM THE SCREENS TO THE STREETS: INTERNATIONAL FANS INTERPRET K-POP FASHION

Five individuals from different parts of the world converged in Seoul's hottest fashion destination, the Dongdaemun Design Plaza, to share their experiences of how K-Pop has influenced their personal style.

Photo Credits
Photographer: Izzy Schreiber

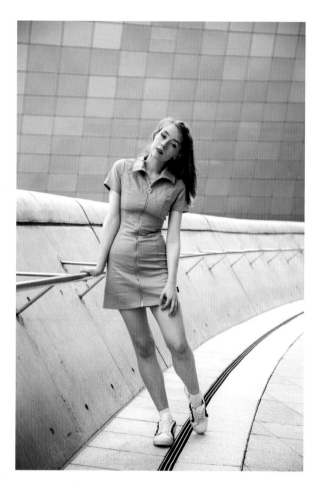

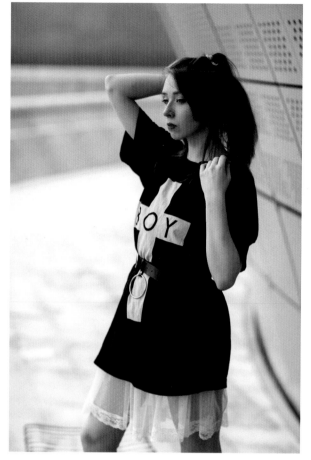

FII CRIDLAND, FROM ENGLAND

Instagram: @fiixii

Fii Cridland's love affair with K-Pop began when she was just twelve years old, but it was through the first generation of stars who promoted themselves outside South Korea. BoA, a solo artist featured in the previous chapter, was making big strides in Japan at that time, and Fii, being more of a J-Pop fan, discovered her and got pulled into the K-Pop fandom instead. "I thought she was really cool and wanted to find out more about her, then I fell into a hole,"

she explained, laughing. Soon, she found herself immersed in different K-Pop groups, some of her favorites including pop-rock band Day6; female quartet Mamamoo; hip-hop, electronic dance BTS; and contemporary f(x); among many others.

It was coincidence, then, when she decided to come to Korea as a language exchange student, and eventually found a job as an English teacher after visiting the country several times. More than the music, Fii learned to love Korea's culture, people, and fashion as she explored and became more familiar with the country.

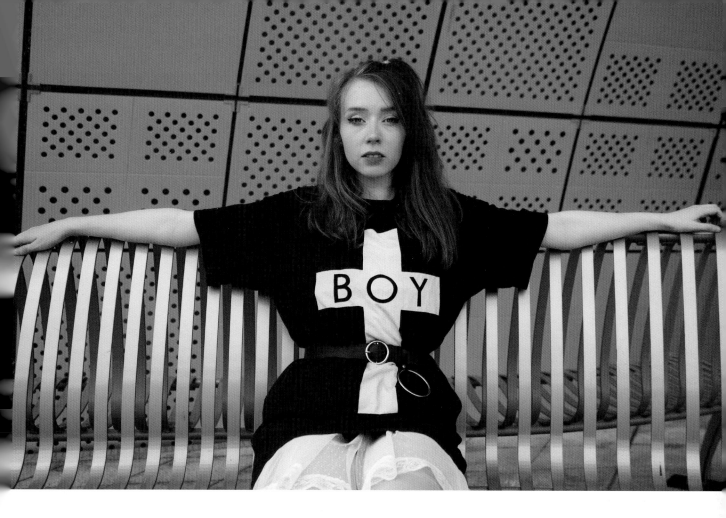

K-Pop fashion has not only changed her look but also her outlook—"I think it's made me more confident in trying new styles and mixing outfits that wouldn't necessarily 'go' together. I think it also inspires me to try and find pieces in stores that I've seen similar in music videos because I like the look. It's also exposed me to a lot of Korean brands, which I think has been the most important thing in helping me find my own personal style, as I generally love a lot of what the brands carry, and the sizing is pretty true to my body type."

And just like her ever-changing taste in K-Pop, her personal style also shows a lot of variety. From streetwear and pastels to a darker, punk-inspired outfit, Fii is always ready to experiment. "Nowadays, I'd describe my style as probably a cross between feminine and edgy. I like getting inspiration from different K-Pop groups whose styles are unique and can easily be emulated."

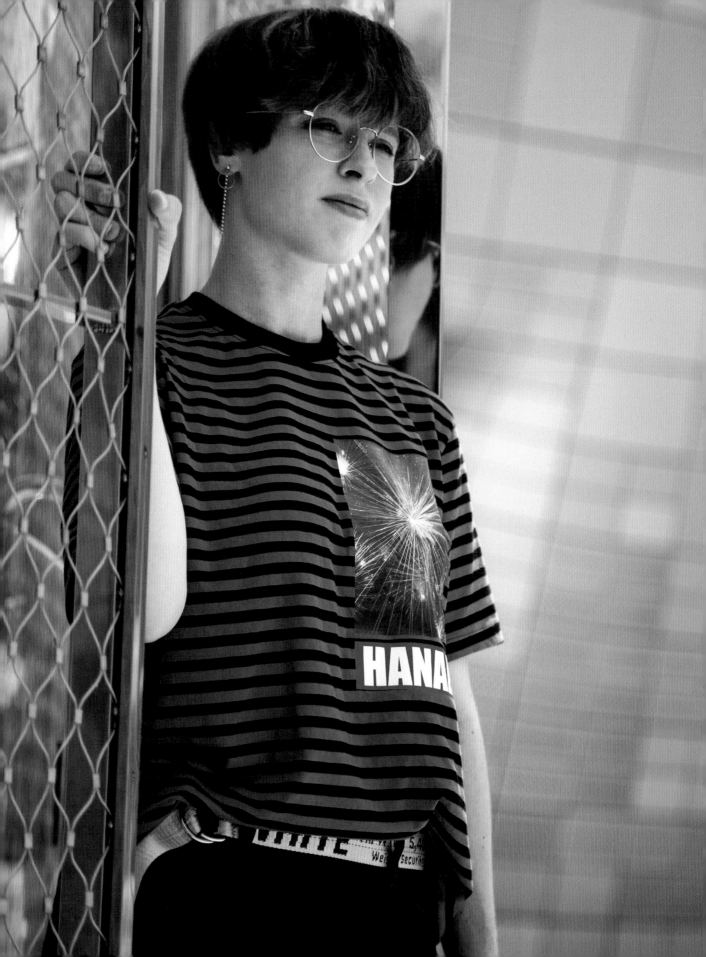

SHELBI MORRIS, FROM KANSAS, USA

Instagram: @ssm_11007

While some people may think that moving to a country that's halfway across the world from your home is quite daring and difficult, for Shelbi Morris, the decision came easily. Her story is a testament to how powerful K-Pop's influence can be, where it turned her simple preference for the music to a life- and career-changing moment. "I originally came here [to Seoul] because of K-Pop, and it has played a big part in keeping me here," she said. "Of course, I wouldn't have stuck it out if I didn't love staying in the country as a whole!"

"I got into K-Pop because of Super Junior. The music was catchy, and a huge focus was put on the visual elements of the music videos and performances. All of the groups I like tend more toward 'traditional' K-Pop, if there's such a thing, where there is a big focus on synchronic dance moves, or the music and performance style being closer to what it was in the late 2000s. I love the pop music and stereotypical 'K-Pop' sound and performance style a bit too much!"

You could also tell that Shelbi is a K-Pop fan at first glance, with her short hair, trendy pants, and overall street style. She used to dye her hair in the same way as her favorite idols, but now that she's job hunting she returned to her natural blond shade. She

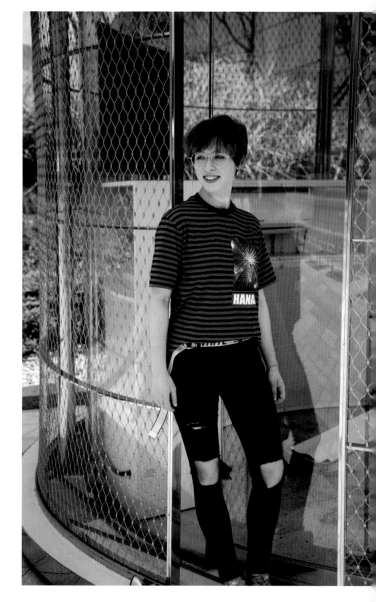

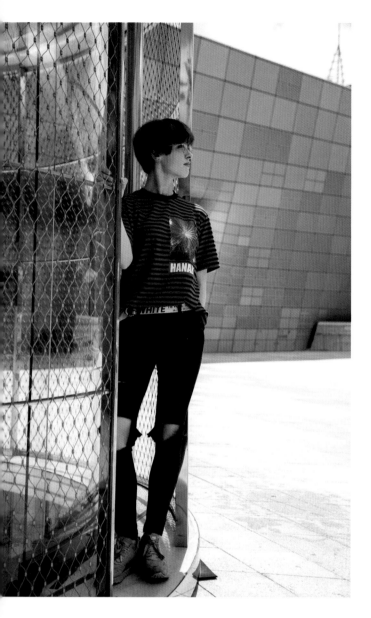

shared that she always cuts her hair short whenever she does K-Pop cover dances, a hobby where she practices and performs K-Pop dances with other fans.

Her style mimics those of her favorite boy bands: Infinite, EXO, ACE, Wanna One, and UNB. "Nowadays I'm into the casual 'dandy' style as they'd call it in Korean, which is more like a modern gentleman fashion. I take a lot of outfit ideas either from the stage or casual outfits of my favorite groups, and have bought a lot of pieces that Baekhyun (of EXO) specifically has worn. My hair being short definitely has the influence of the K-Pop guy groups."

When asked if her style was drastically changed by K-Pop, her answer is a resounding, "Yes! It's given me more ideas to try out new styles and colors and pattern combinations, and given me the confidence to just wear what I want and make it work. I think the confidence is a big part of making anything look good."

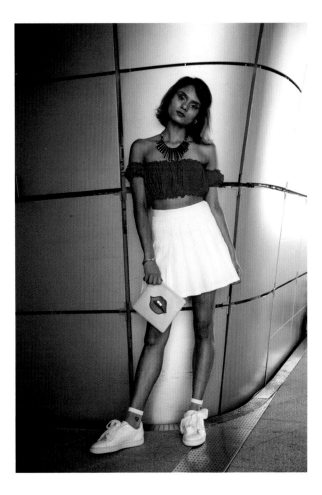

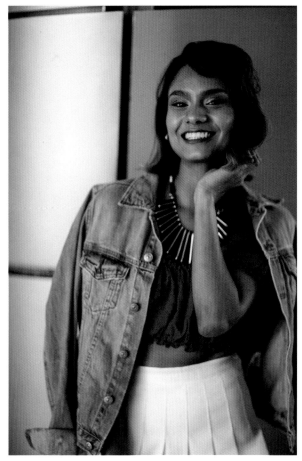

JASPREET KAUR,
FROM SAN DIEGO, USA

Instagram: @jazzitar

Jazz Kaur dreams of making it big in the modeling and acting *biz*—but not in her hometown in San Diego, where she grew up. She flew all the way to South Korea to pursue this dream after discovering her love for the country as an exchange student from UC–San Diego to Yonsei University in Seoul. Even prior to that, however, she was already a fan of Korean dramas and eventually, K-Pop. "The highly well-produced music videos, the interesting story lines, unique music and singing styles, as well as the fashion, attracted me to most of the K-Pop groups," she shared.

Her love for boy band BTS runs deep. "When I first discovered them, I realized there was something different about them. Their music was very much geared toward breaking out of molds that society has fit us into and many of their songs touched upon themes of stereotyping and youth empowerment. I had no idea then that BTS would one day sweep up a storm in America. It felt like I woke up one day and

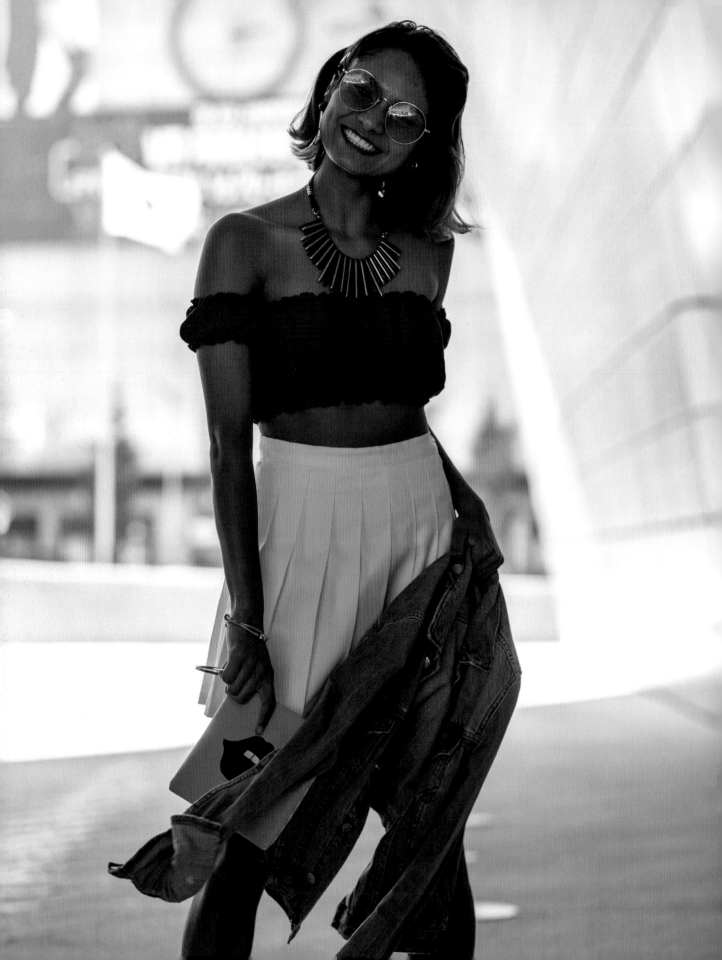

all of a sudden, everyone knew who BTS was!"

For her, the group is not just some superficial crush—they are a source of her inspiration. "Their music gives me courage to keep pursuing my dreams. They pulled me out of the dark during the lowest point in my life and for that, I am forever grateful I had their music."

She loves BTS so much that she recounted the time when she went to six different stores just to look for the brand of shoes that the boys were endorsing. But this isn't the first time her style was influenced by Korean pop culture, as she was often drawn to the styles of K-Pop stars BLACKPINK, EXID, Red Velvet, BTS, and Hyuna and actresses such as Jung So-min, Park Shin-hye, Lee Sung-kyung, and Kim So-eun.

"I often try to take inspiration from the looks I see in dramas, music videos, and variety shows. I do not try to directly copy the styles but very much of my style is 'Koreanized' in way," she said. And just like the others whose lives were touched and changed by K-Pop, she considers the value of the genre as more than a typical kind of enjoyment or a hobby to pass time. "K-Pop helped me to become more confident in getting a little more creative in the looks that I wear without feeling foolish. Clothes that I felt were a bit over the top before, accessories I thought were too excessive, or even makeup that I did not think suited me became more fun to try out," she said.

"K-Pop and Korean dramas have influenced my dream because it made me fall in love with Korean fashion!"

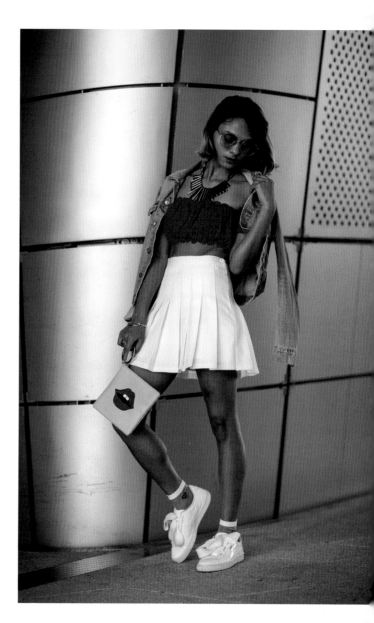

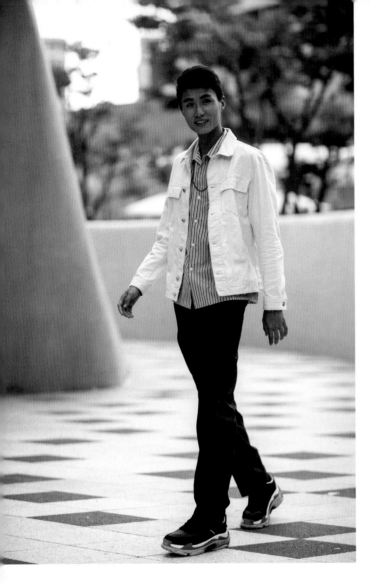

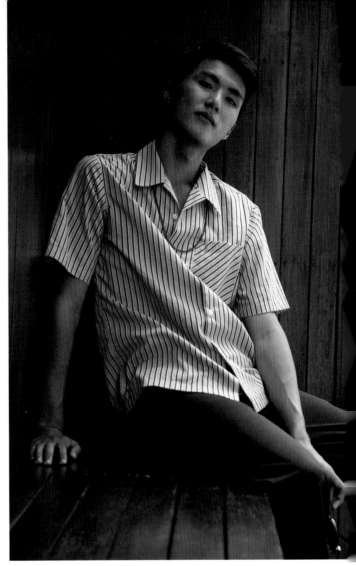

MELVIN ONG, FROM SINGAPORE

Instagram: *@melvinoyx*

You'll notice some things when you browse vlogger and university student Melvin Ong's Instagram feed: colorful cafés, trendy shops, stylish OOTDs (outfit of the day), and an overall visually pleasing aesthetic that makes his 18,000-strong following continue to grow. His secret? He often jets to and from his home in Singapore to South Korea, which provides the best backdrops to his travel photos and perfectly captured moments. "I first came because I enjoyed listening to the old K-Pop back in 2007, which made me want to see Korea for myself. This is my sixth time here and I got into a language exchange program in Seoul. It gets addictive and I kept coming back for the cafés, the music, the festivals, and the scenery," he shared.

Contrary to the idea that K-Pop is mostly composed of fangirls, Melvin considers himself as a fanboy to one of Korea's most

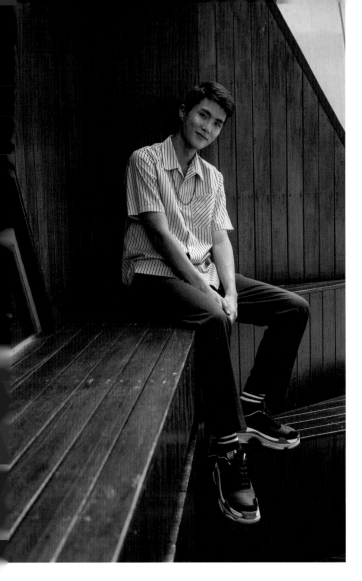

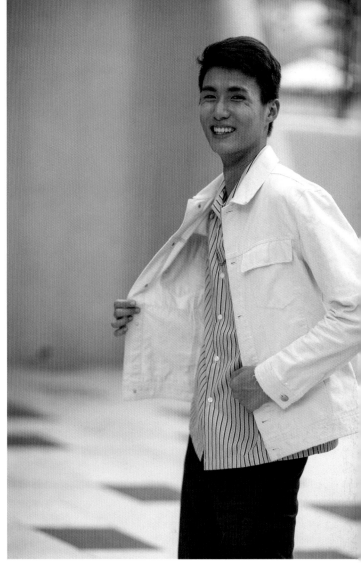

recognizable girl groups, Girls' Generation. "Their flawlessly synchronized dance moves are mesmerizing," he remarked. "Oh, I have been through that phase where I did what some might consider as 'extreme' things for the love of K-Pop. I've been to about fifteen K-Pop concerts to date. But that was many years back. Nowadays I simply appreciate the music and go here to experience Korean culture."

Not only did Seoul become his favorite destination, Korean fashion has also given his own personal style a big boost. Melvin considers his style prior to his discovery of K-Pop as pretty typical, saying "My style was definitely not as exciting and special compared to now. K-Pop has really opened many opportunities for me to look at different styles and most up-to-date trends. It breaks certain stigmas of what it means to be 'stylish.'"

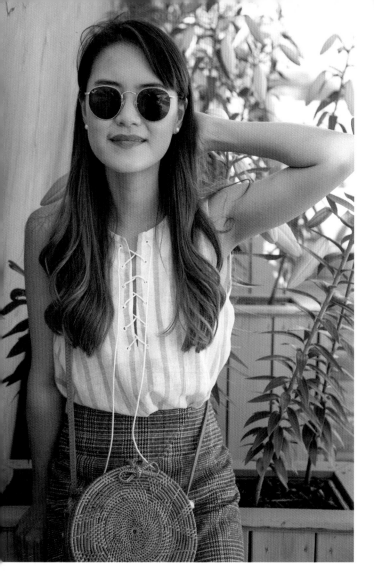

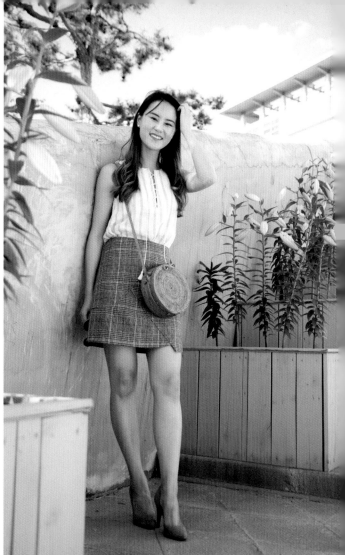

KIEUN CHOI, FROM SEOUL, SOUTH KOREA

Instagram: @kieunchoi

Kieun Choi is of Korean descent and was born in Korea before her family moved to the United States when she was just four years old. Being far from home and with little knowledge about Korean language and culture, Kieun strived to connect to her roots through frequent visits to the country and by watching Korean dramas. "All I knew about Korea was from dramas, variety shows, and music," she shared.

When she studied at Seoul National University as an exchange student, she realized, "I started to dream a new goal: becoming an announcer in Korea. That's why I moved back to Korea in 2016 by myself."

Her first foray into the fandom was when she visited Korea in 2007 with her family and she got to know about boy bands like Big Bang and SHINee. "The middle-school girl

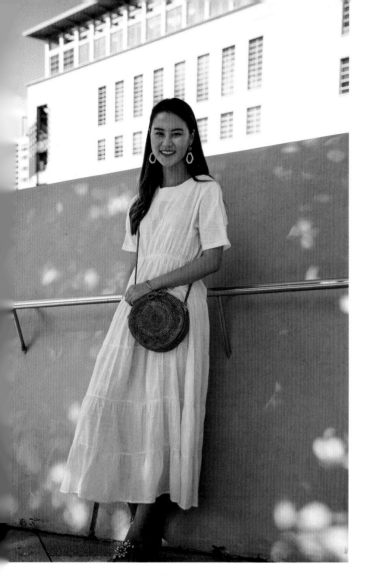
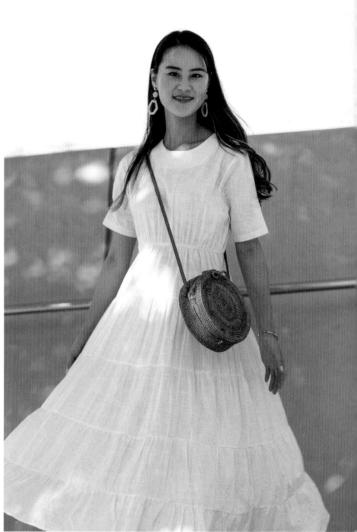

inside me swooned at all these handsome guys with beautiful voices," she said. "I would put up posters of Big Bang and SHINee everywhere in my room. I also remember ordering a pair of G-Dragon earrings in middle school. I thought they were so cool and I wore them all the time!"

But more than K-Pop music, it was Korean dramas that influenced her style. "In the [Korean] music industry, they wear more unique outfits and makeup since they are performing onstage. So for everyday wear, dramas and variety shows offer better ideas for style. I sometimes look at certain celebrities' personal Instagrams for inspiration on daily looks."

While she still kept true to her feminine style, Kieun shared that Korean beauty and fashion changed her preferences and the way people see her look. "I got into the Korean makeup style of fresh looks like pink blush and natural finish versus the sexy and smoky look that's popular in America," she said. "My friends in America tell me that I've become 'so Korean' now, and I love it!"

Chapter 5:

ALL THAT GLOWS

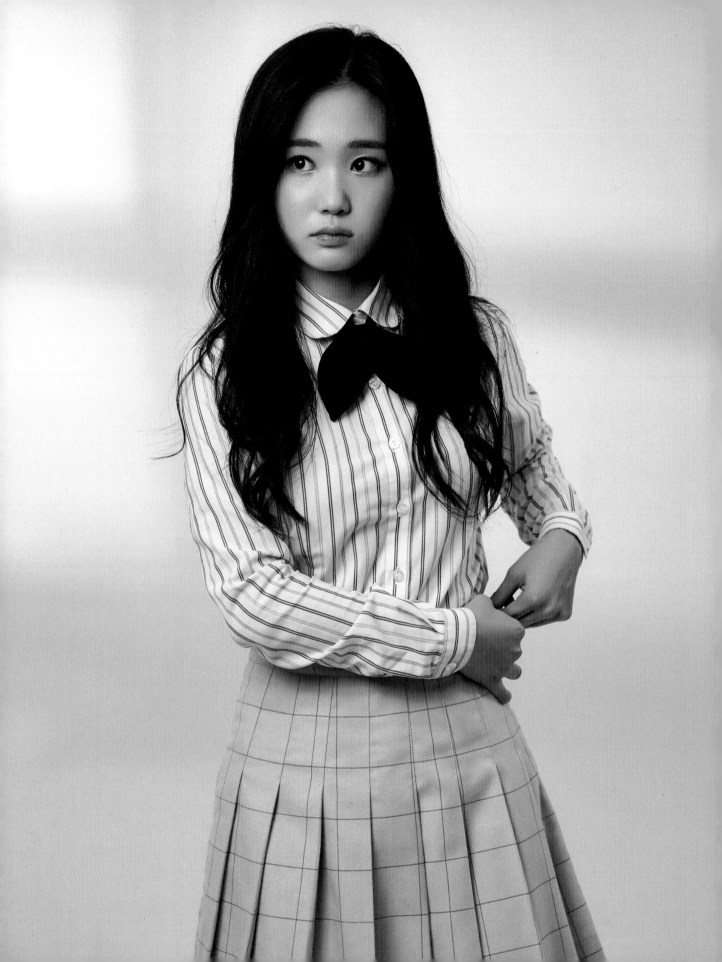

ALL THAT GLOWS: K-BEAUTY MAKEUP

Aside from the worldwide popularity of Korean entertainment and fashion, another industry is enjoying its moment in the sun: K-Beauty. Just like K-Pop styles provide the mood board for fans to emulate, makeup looks are also an inseparable part of it. Here are some quintessential makeup styles that complement the ultimate K-Pop looks:

Photo Credits
Photographer: Sewon Jun
Fashion Stylist: Kyunghoon Back
Makeup and Hairstylist: Sooho Yoon

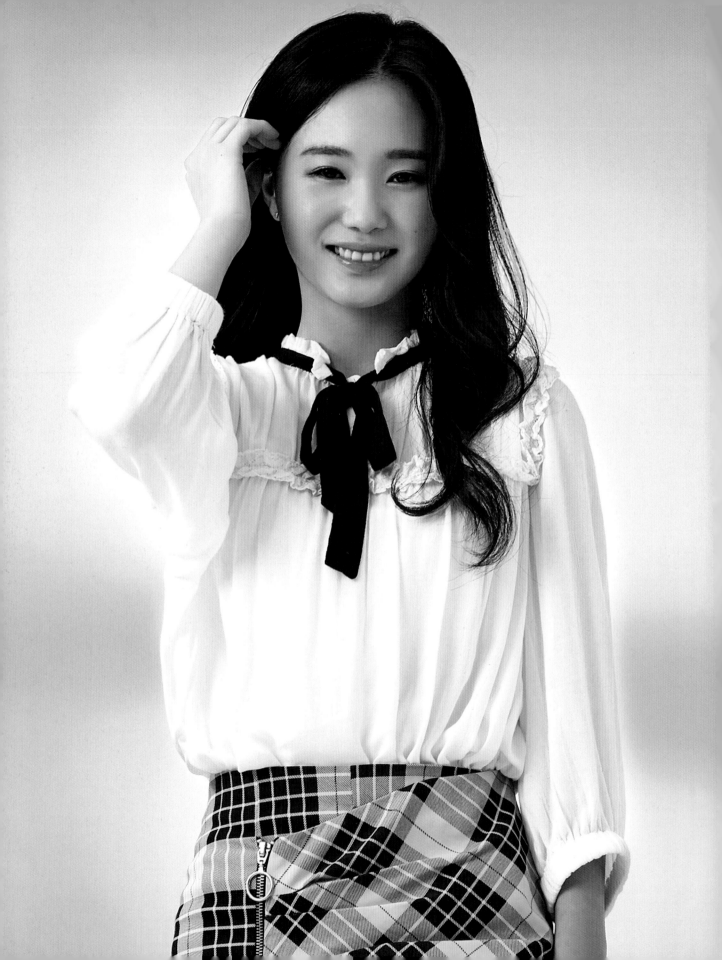

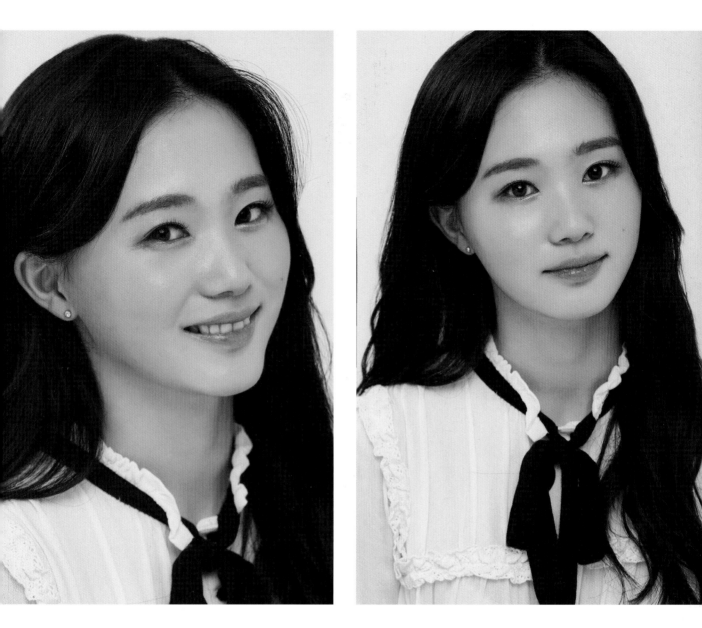

YOUTHFUL AND CUTE

Koreans put emphasis on clear, clean skin when it comes to makeup, which is why heavy makeup looks are a big no-no both on screen and off. This is especially true for girl groups whose concepts are lively, young, and cute, so a simple, sweet look is preferred. This style includes the following elements: straight brows, light base, and touches of pink on the eyes and glossy lips. Unlike the Western style of making one's features pop out through curly lashes, contour, and bold lips, the Korean style is more about bringing out a flawless, beautiful skin that stays true to one's looks.

HIGH SHINE

In Korea, a moist, dewy skin is always in style because for them, a glowing complexion means fresh, youthful, and well rested. Instead of mainly relying on highlighters, a hydrating air-cushion foundation is used to achieve this look. This evens out and corrects the skin tone without making it look flat and dry. A pink shade, light brown eyeliner, a touch of shine under the eyes, and red lips are applied to create a doll-like look.

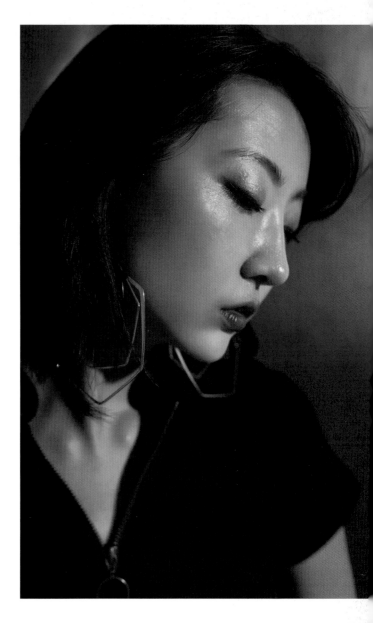

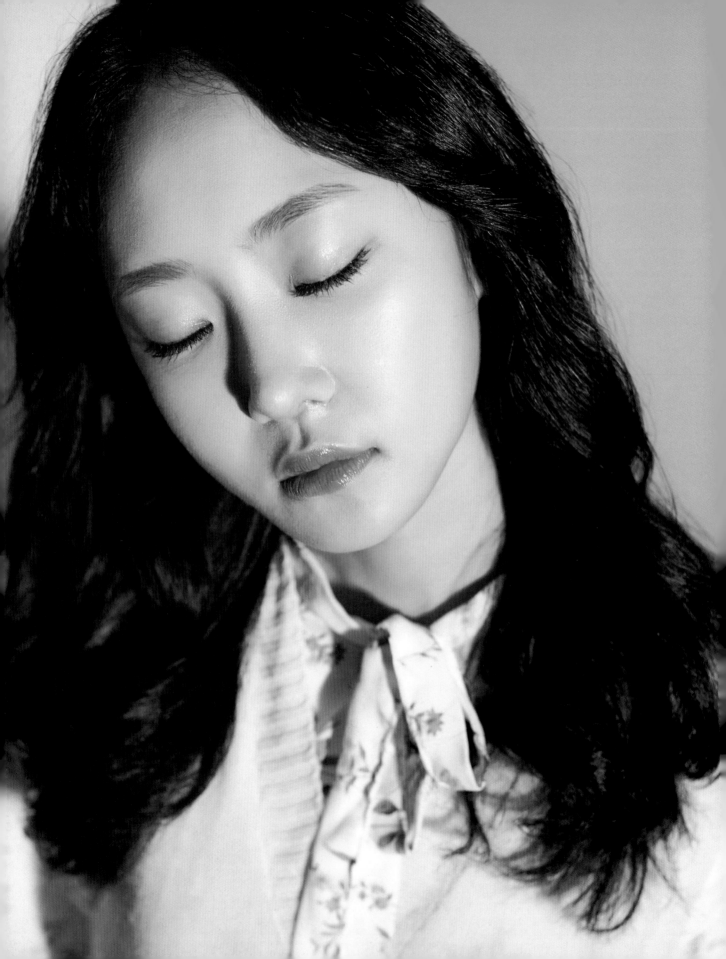

GLASS SKIN

This look is perfect for spring: peach, baby pink, and coral tones with a dewy glow. It's a fresh daily look that accentuates a smooth face. While it seems easy to achieve, this look is all about creating a "glass skin," a popular trend that results in a gleaming, translucent, and porcelain effect. Prior to application of makeup, an intricate skin care routine is done to cleanse, tone, and moisturize the skin. Foundations with hydrating formulas are also used to add a nice sheen.

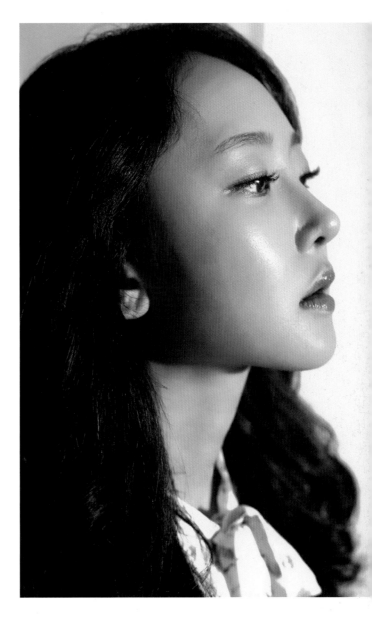

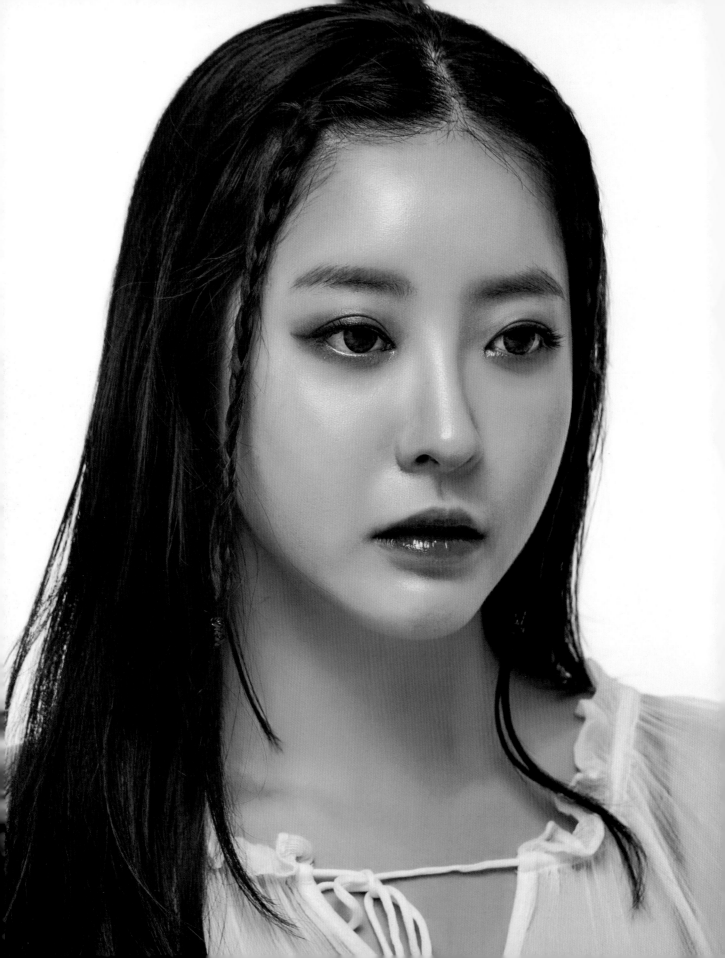

SUBTLE GLAM

The ombre, gradient lip look is quite a staple when it comes to K-Pop makeup. To achieve it, a lighter color is applied to the outer part of the lips while gradually making it darker in the middle. This is combined with a cat-eye technique to emphasize the shape of the eyes.

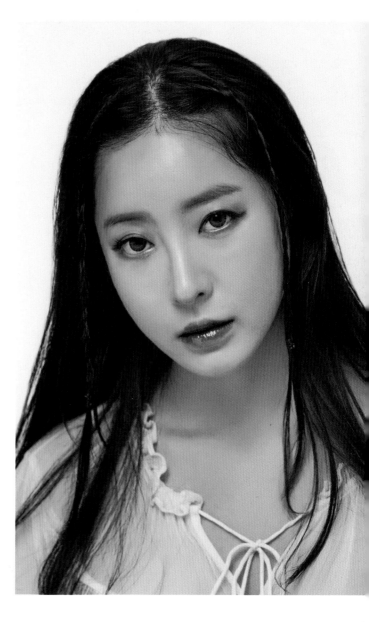

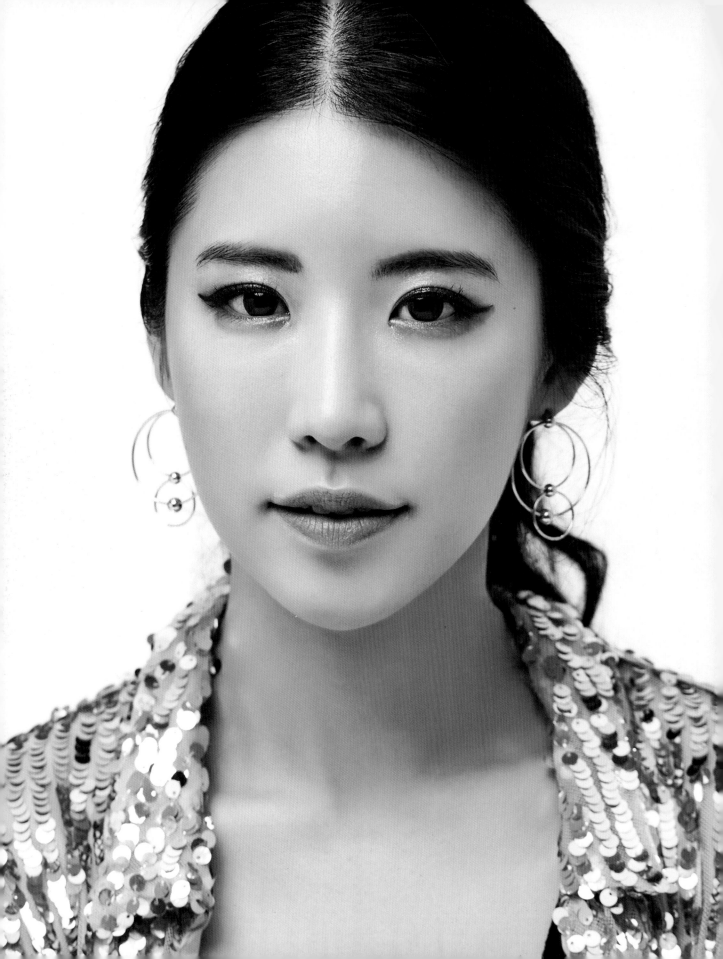

EDGY COOL

The perfect, dramatic black wing is important in creating a fierce look. This is usually seen in K-Pop styles that have edgy, street concepts. This is achieved by doubling the eyeliner as it is applied on the edge of the eyes, with the darkest eyeshadow used closest to the upper waterline. A more natural matte lip color is used to balance the look.

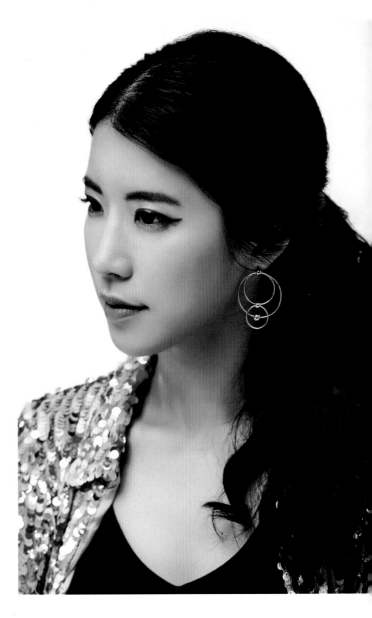

Chapter 6:

THE KOREAN SKIN CARE ROUTINE AND WHY THE WORLD LOVES IT

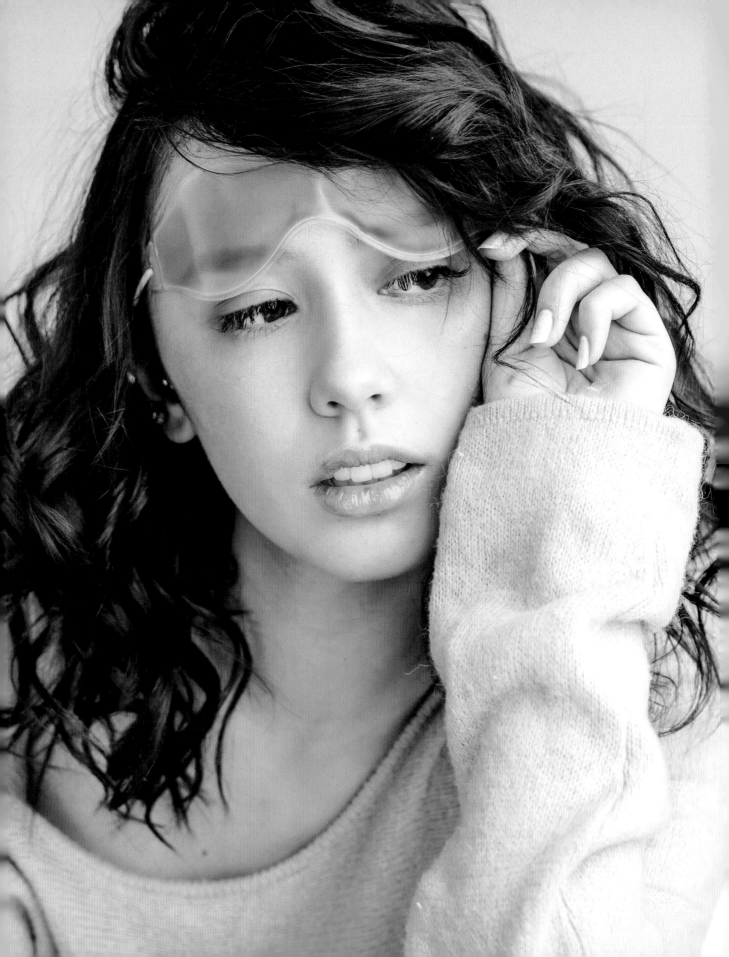

CHAPTER 6

THE KOREAN SKIN CARE ROUTINE AND WHY THE WORLD LOVES IT

It's a fact: Koreans are completely invested in their skin care as though it's a necessity for everyday life. According to a report by the BBC, "South Korean women spend twice as much of their income on beauty products and make-up as their American counterparts. Meanwhile, South Korean men spend more on skincare than those in any other country." Their daily and nightly skin care steps range from the usual cleansing, toning, and moisturizing, to a more extensive routine that reaches up to ten steps. This meticulous process is borne out of their desire to have a flawless, luminous complexion, which, to them, is a sign of youth and, ultimately, diligence.

What makes Korea's skin care distinct from others is that it combines modern technology with age-old ingredients that the locals believe to have incredible benefits to the skin. Natural ingredients that may sound quite extreme and unbelievable are pretty common in beauty products; for example, snail slime cream, volcanic lava, pig collagen jelly cream, bee venom, fish eggs, and placenta.

Here are some of the latest skin care steps that have caused a craze in South Korea and beyond.

Photo Credits
Photographer: Rxandy Capinpin
Hair and Makeup: Hannah Pechon
Model: Jean Malcolm

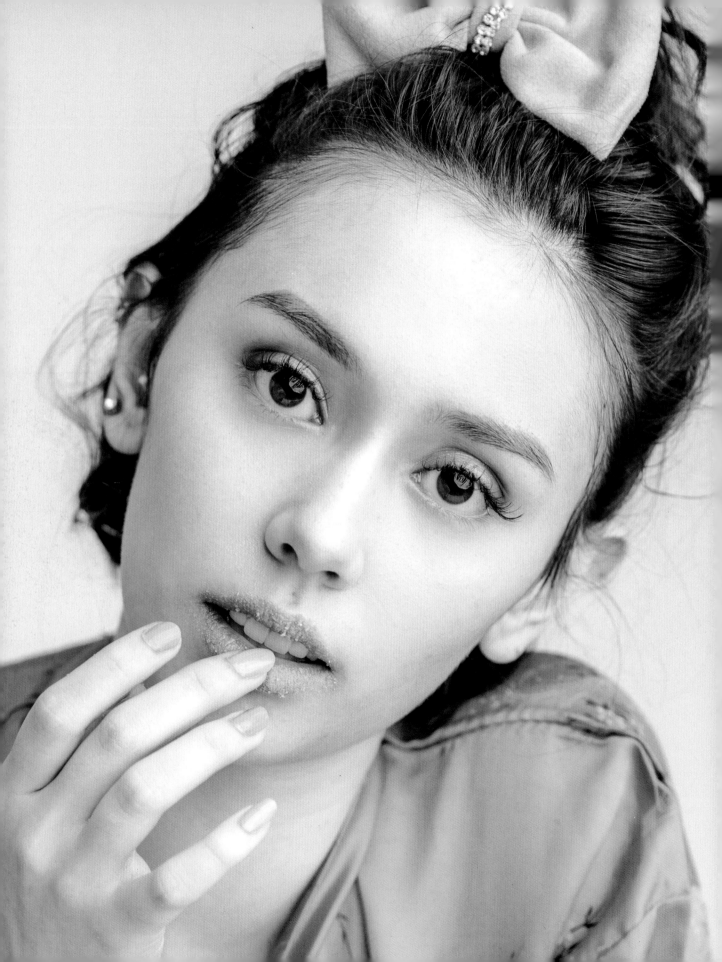

LIP SCRUB

Koreans are light years ahead when it comes to beauty innovations, and the bubble lip mask, one of their greatest offerings, beats the common lip balm. This bubble lip mask is basically a scrub that aims to exfoliate and get rid of dead skin cells on the lips, making them softer and smoother. It also provides hydration and moisture to the lips, which makes it perfect for use in cold weather.

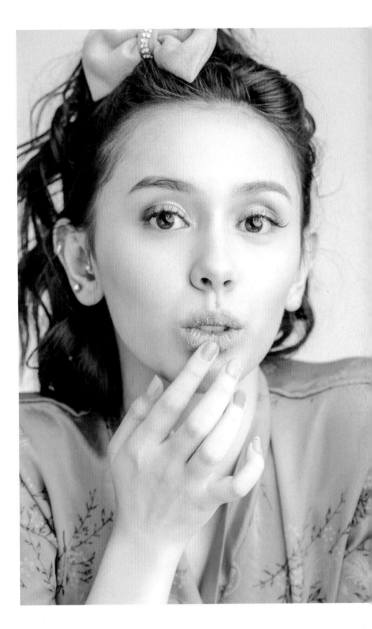

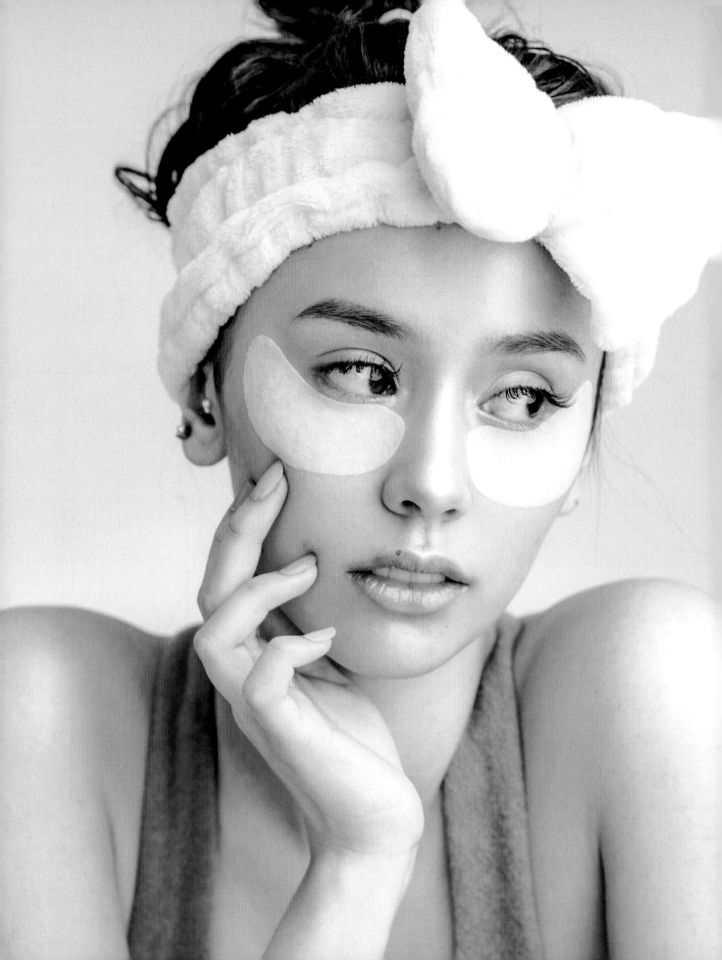

EYE MASK

There are several Korean products that address dark circles and under-eye wrinkles. One of them is the quintessential eye patch that adheres to the skin. It aims to make the skin firmer and lighter under the eyes, and it has a cooling effect that refreshes the skin.

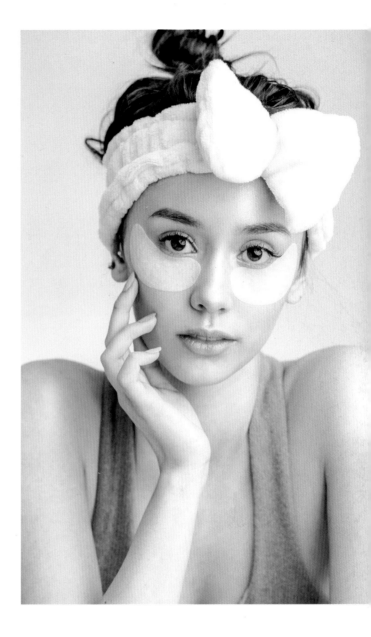

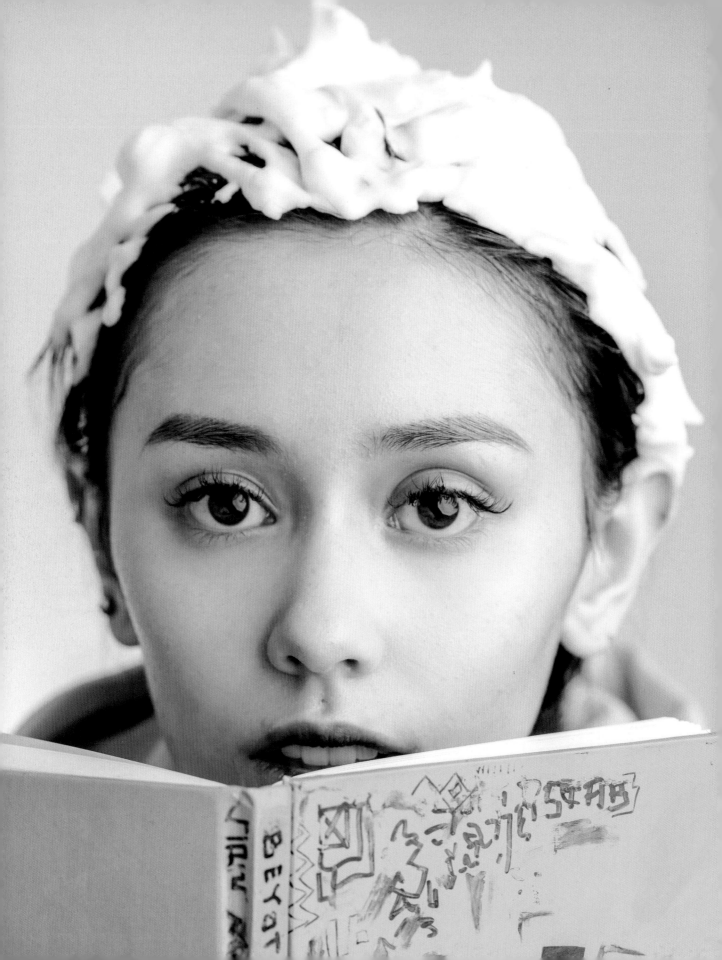

BUBBLE HAIR DYE

Rather than sit and wait in the salon for hours to get a new hair color, Koreans have found an easier, faster alternative: bubble hair dye. It is applied on dry hair and stays on for about 30 minutes. The bubble texture not only makes application easier, but the color will also be distributed evenly on the hair. It also does not stain the skin, which is a welcome innovation that saves time and hassle.

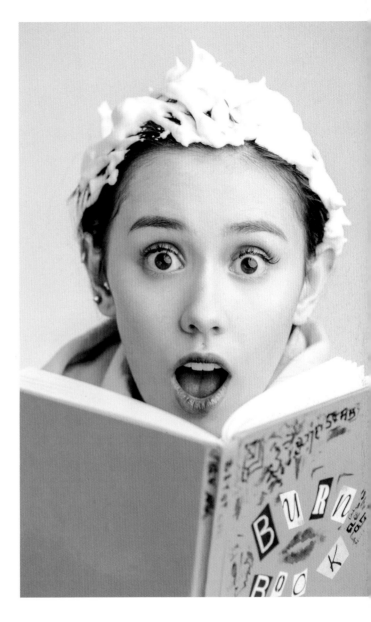

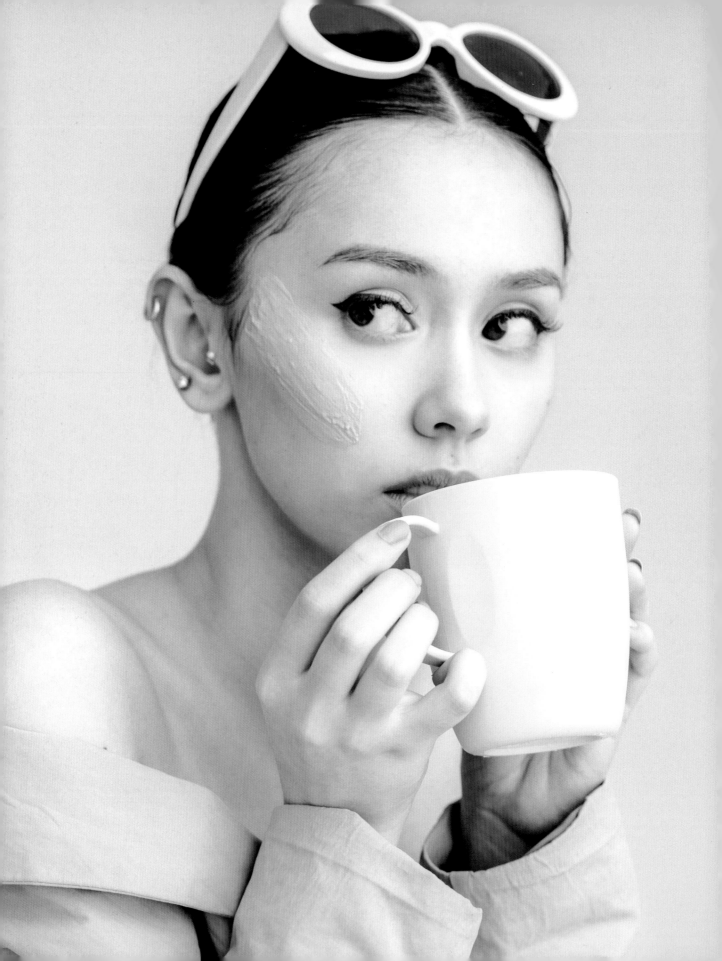

HEALING CLAY MASK

Korean clay masks are designed to clear pores of dirt and impurities, and are also used to reduce acne, scars, and uneven skin tone. Some masks include ingredients like volcanic ash, charcoal powder, black sugar, and rice, to name only a few. These masks deliver clarifying, oil-reducing, and skin lightening properties.

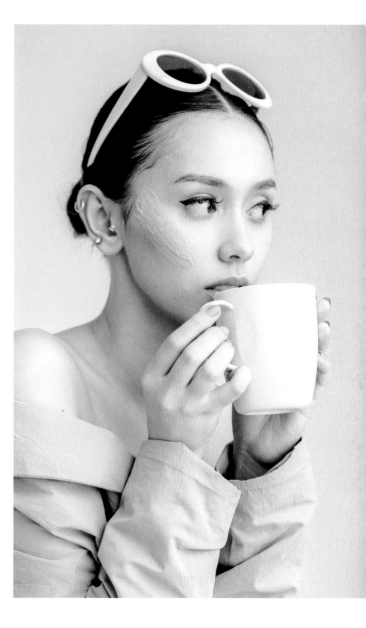

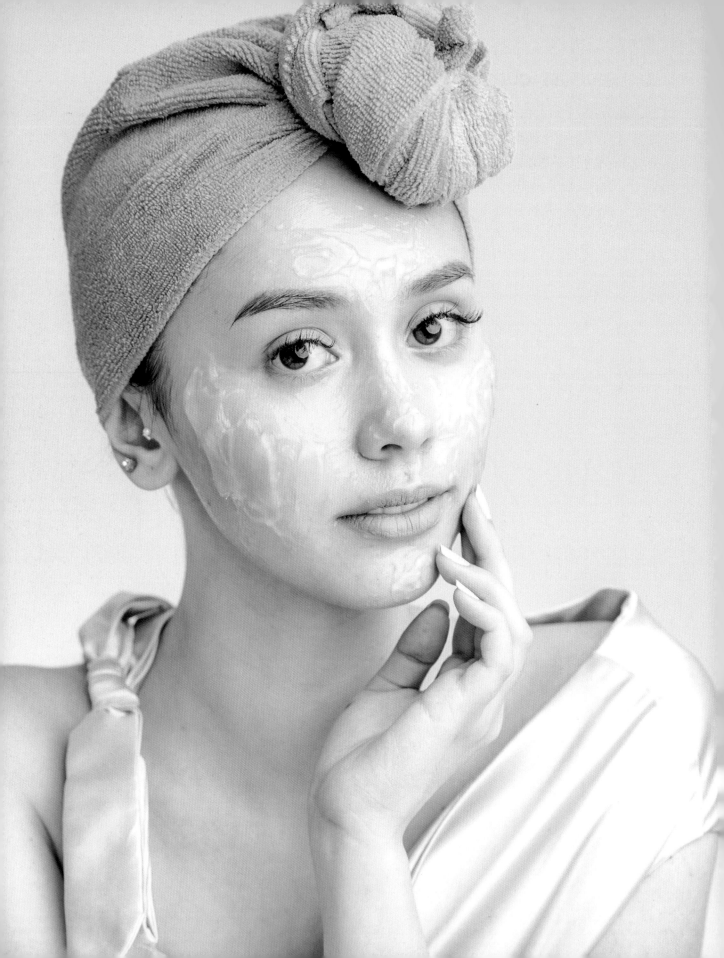

COOLING GEL CREAM

Hydration is one of the main purposes of gel creams, and some Korean products have a cooling effect to soothe and brighten the skin. The light, watery, gel-like facial formula is also perfect for oily and sensitive skin types.

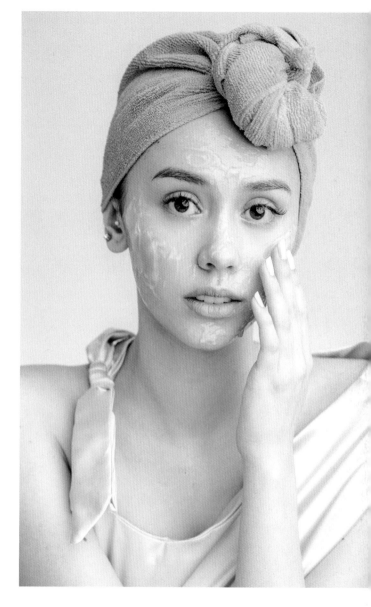

Chapter 7:

K-POP AS THE NEXT BIG THING IN FASHION

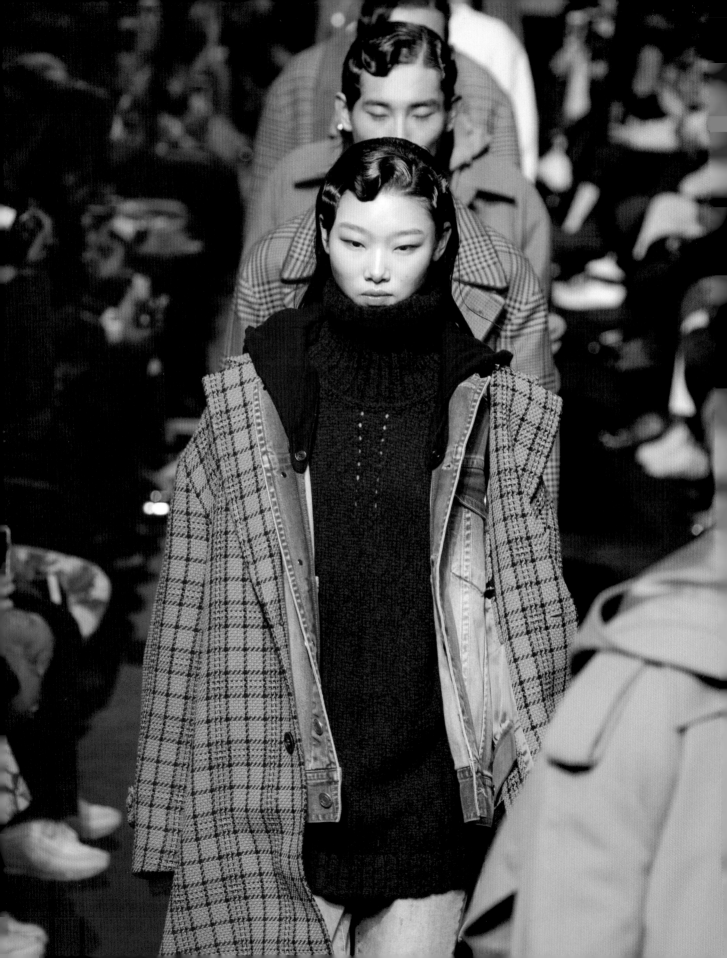

CHAPTER 7

K-POP AS THE NEXT BIG THING IN FASHION

At the Paris Charles de Gaulle Airport, an unusual frenzy could be seen as a large number of French fans eagerly waited at the arrival gates, holding up welcome signs, flowers, and teddy bears to gift the special guest. The crowd was getting impatient, but once they caught a glimpse of Jennie Kim—a member of the girl group BLACKPINK, whose fresh face doesn't give the slightest hint of her jet lag after a long flight from Seoul—they rushed toward her for photos and hoped to shake her hand. She is, after all, one of Korea's newest and biggest acts to attend the launching event of Chanel's new fragrance, Les Eaux De Chanel, in Deauville, France. She flew in as one of Chanel's brand ambassadors and muses alongside American actress Yara Shahidi, French actress Alma Jodorowsky, and Japanese model Tao Okamoto, among many other prominent personalities from around the world.

At the 2018 Cannes Film Festival, Jessica Jung, singer and creative director of her own fashion brand, walked the red carpet in a head-turning lilac Ralph & Russo tulle gown as the paparazzi clicked away.

Sehun, a member of boy band EXO, was also spotted making rounds in another Fashion Week, with *Vogue* running an article about him titled, "Sehun is the Best-Dressed Man at Louis Vuitton's Show Yet Again."

K-Pop stars modeling for designer brands and sitting front row at runway shows is becoming more common, now that the genre has secured a place in the mainstream consciousness of the exclusive fashion world. Their influence is seen as remarkable, not just with album sales but also their ability to sell the apparel and accessories they wear.

After all the attention given to K-Pop, the world is looking toward what Korea will come out with next, in addition to its catchy music and colorfully dressed stars. In 2015, *Grazia*'s Bethan Holt predicted Korean fashion to be "the Next Big Thing," and said that it's "time to get serious about Korean fashion." She wrote further, "From a fashion perspective, it seems like the talent emerging from Korea is also anticipating how we'll be dressing into the future. It won't be about trends exactly, but how we

<< Photographer: Izzy Schreiber
Designer Munn is one of the top trendsetters most watched by Seoul's fashionable youth.

express ourselves through clothes and the way they work for us."

Innovative Korean designers are now getting the spotlight as they participate in the bigger world stage of international Fashion Week shows. Domestically, up-and-coming Korean designers and their following are gaining traction as they present their collections at the "Generation Next" shows during Seoul Fashion Week.

The K-Pop industry is also changing. The novelty of this once fascinating entertainment world is fading in terms of it being no longer something "new." News about K-Pop boy band BTS performing at a sold-out concert in New York is no longer unexpected. Soon, news about K-Pop stars attending or modeling for the who's who in fashion will be something quite common or will simply be stated as a matter of fact. Not that it's a bad thing; in fact, the world's familiarity with K-Pop is an achievement in itself. However, a bigger challenge is posed to K-Pop and all the things that come along with it, whether it be fashion, dramas, food, or Korean culture: How can these stay relevant in this day and age where "viral" or "trending" talents are emerging every day?

But surely, K-Pop is here to stay. It has the immense ability to stay current with the high turnover of new groups, new sounds, and new faces. There will always be something to look forward to. Veteran and iconic K-Pop stars are also up to the task. As G-Dragon self-assuredly and confidently sang in his song "One of a Kind," "Let everyone you meet know, I'm the first class of the celebrity world. Because I'm different, because that's just me, because people go crazy over anything I do. Because I create trends, because I change everything, so this skill isn't going anywhere."

SOURCES

Arthur, Golda. "The key ingredients of South Korea's skincare success." BBC News. January 28, 2016. https://www.bbc.com/news/business-35408764.

Bai, Stephany. "K-Pop Star Jessica Jung on Identity, Fashion, and Life after Girls' Generation." NBC News. December 15, 2016. https://www.nbcnews.com/news/asian-america/k-pop-star-jessica-jung-identity-fashion-life-after-girls-n696161.

Benjamin, Jeff. "Red Velvet Earn Their Best Song Sales Week in the US Yet with 'Bad Boy.'" *Billboard*, February 8, 2018. https://www.billboard.com/articles/columns/k-town/8098865/red-velvet-bad-boy-best-song-sales-week-world-digital-songs-chart.

Glasby, Tyler. "G-Dragon: 'There's no right answer in fashion.'" *Dazed*, February 8, 2017. http://www.dazeddigital.com/fashion/article/34630/1/talking-fashion-with-g-dragon-k-pop-interview-peaceminusone.

Glasby, Tyler. "Meet the Girl Group Breaking K-Pop's Rules." *Dazed*, October 12, 2016. http://www.dazeddigital.com/music/article/33328/1/red-velvet-k-pop-interview.

Herman, Tamar. "K-Pop Icon BoA Discusses 'One Shot, Two Shot' EP, Aging & K-Pop's Global Appeal: Exclusive." *Billboard*, March 5, 2018. https://www.billboard.com/articles/columns/k-town/8231980/boa-interview-one-shot-two-shot.

Herman, Tamar. "Red Velvet Talks 'Perfect Velvet' Album, Changing Up Their Style for 'Peek-A-Boo.'" *Billboard*, November 17, 2017. https://www.billboard.com/articles/columns/k-town/8039386/red-velvet-interview-perfect-velvet-album-peek-a-boo.

Herman, Tamar. "Red Velvet Drops Perfectly R&B-Laced 'Bad Boy.'" *Billboard*, January 28, 2018. https://www.billboard.com/articles/columns/k-town/8096961/red-velvet-bad-boy.

Hgordon. "The 12 Craziest Korean Face Mask Ingredients You'll Ever See." Soompi, September 12, 2018. https://www.soompi.com/article/1226185wpp/12-craziest-korean-face-mask-ingredients-youll-ever-see.

Holt, Bethan. "Korean Fashion Is the Next Big Thing." *Grazia*, February 16, 2015. https://graziadaily.co.uk/fashion/news/korean-fashion-next-big-thing/.

Hong, Euny. *The Birth of Korean Cool: How One Nation Is Conquering the World through Pop Culture.* New York: Picador, 2014.

Jardine, Jessica Jean. "Jeremy Scott and CL on Moschino, Pop Culture and the Power of Girls." *Paper*, August 26, 2015. http://www.papermag.com/jeremy-scott-mochino-cl-1427634656.html.

Kim, Monica. "Bajowoo Is the Breakout Designer Korea Has Been Looking For." *Vogue*, October 21, 2016. https://www .vogue.com/article/99-percent-is-bajowoo-seoul-fashion-week-spring-2017.

Kim, Monica. "Is EXO the Most Stylish Pop Band of All Time?" *Vogue*, July 28, 2017. https://www.vogue.com/article/exo-k-pop-photos-portraits-kokobop-comeback-fashion-style.

Kim, Sohee. "The $4.7 Billion K-Pop Industry Chases Its 'Michael Jackson Moment.'" *Bloomberg Businessweek*, August 22, 2017. https://www.bloomberg. com/news/articles/2017-08-22/the-4-7-billion-k-pop-industry-chases-its-michael-jackson-moment.

Mahr, Krista. "South Korea's Greatest Export: How K-Pop's Rocking the World." *Time*, March 2, 2012. http://world.time .com/2012/03/07/south-koreas-greatest-export-how-k-pops-rocking-the-world/.

Matsumoto, Jon. "Why Is K-Pop's Popularity Exploding in the United States?" Grammy .com, May 15, 2017. https://www.grammy .com/grammys/news/why-k-pops-popularity-exploding-united-states.

Ming, Cheang. "How K-Pop Made a Breakthrough in the US in 2017." CNBC, December 29, 2017. https://www .cnbc.com/2017/12/29/bts-and-big-hit- entertainment-how-k-pop-broke-through-in- the-us.html.

New York Times. "Can K-Pop Conquer America?" June 30, 2017. https://www .nytimes.com/2017/06/30/arts/music/ popcast-kpop-kcon.html.

Peng, Elizabeth. "G-Dragon, the Undisputed King of K-Pop, Takes New York." *Vogue*, July 31, 2017. https://www.vogue.com/ article/g-dragon-act-3.

Rahman, Abid. "Fuelled by Fashion, the Korean Wave Is Taking the World by Storm." *South China Morning Post*, October 23, 2015. https://www.scmp.com/magazines/ post-magazine/article/1870798/fuelled- fashion-korean-wave-taking-world-storm.

Romano, Aja. "How K-Pop Became a Global Phenomenon." *Vox*, February 26, 2018. https://www.vox.com/ culture/2018/2/16/16915672/what-is-kpop- history-explained.

Satran, Rory. "CL Dishes on 'Hello Bitches' and Her New Badass Style." *i-D*, November 21, 2015. https://i-d.vice.com/en_us/article/ bjzby5/cl-dishes-on-hello-bitches-and-her- new-badass-style.

Schiller, Rebecca. "BTS Talk Personal Style Influences and the Importance of Fashion in Music: Watch." *Billboard*, February 16, 2018. https://www.billboard.com/articles/news/bts/8099949/bts-interview-style-fashion-music-video.

Sidell, Misty White. "The Style Secrets Behind K-Pop's Most Fashionable Girl Group." *WWD*, June 15, 2018. https://wwd.com/fashion-news/fashion-features/the-style-secrets-behind-k-pops-most-fashionable-girl-group-1202709855/.

Stern, Bradley. "K-Pop Girl Group EXID Channels '90s Nostalgia in 'Lady.'" *Paper*, April 6, 2018. http://www.papermag.com/k-pop-exid-interview-2556886521.html.

Williams, Maxwell. "Get to Know K-Pop Girl Group Blackpink." *Nylon*, December 6, 2016. https://nylon.com/articles/blackpink-interview-nylon-december-january-2017.

Zhang, Jing. "'Asia is the future,' Karl Lagerfeld Says as Chanel Holds Korea Show." *South China Morning Post*, May 9, 2015. https://www.scmp.com/lifestyle/fashion-luxury/article/1789373/karl-lagerfeld-staged-chanel-cruise-show-korea-because-asia.

ABOUT THE AUTHOR

ABOUT THE AUTHOR

Dianne Pineda-Kim is an online editor and writer for various print magazines and websites in Korea. She writes about K-Pop fashion trends and entertainment features for Soompi.com, a division of Viki Inc., the world's largest and longest-running English online medium providing complete coverage of Korean pop culture. She also writes for *Groove Korea*, a travel and lifestyle magazine widely distributed all over South Korea, and *10 Magazine Korea*, a website for expats living in Korea. She also did a feature coverage on Seoul Fashion Week SS/2019 for CNN Style. She was an editor for *Hinge Inquirer* and *Hola! Magazine* in Manila before she started doing digital work and moved to South Korea to marry the love of her life. She's been a fan of K-Pop and K-Dramas since 2007, and her current favorite groups are Big Bang, BLACKPINK, BTS, Infinite, Red Velvet, and Twice, among many others. Follow her on Instagram at @dianne_panda.